REMAKE

MASTER WORKS OF ART
REIMAGINED

REMAKE

CHRONICLE BOOKS
SAN FRANCISCO

JEFF HAMADA

MASTER WORKS OF ART REIMAGINED

REMAKE

CHRONICLE BOOKS
SAN FRANCISCO

JEFF HAMADA

Library of Congress
Cataloging-in-Publication
Data available.

ISBN: 978-1-4521-2334-9

Manufactured in China.

10 9 8 7 6 5 4 3 2 1

Chronicle Books LLC
680 Second Street
San Francisco, CA 94107

www.chroniclebooks.com

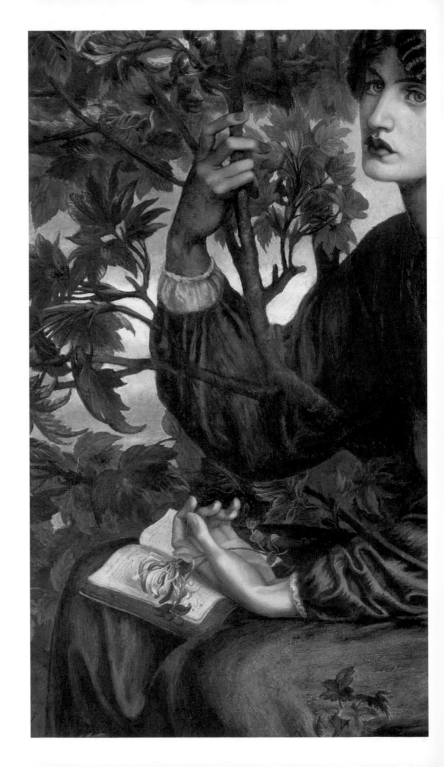

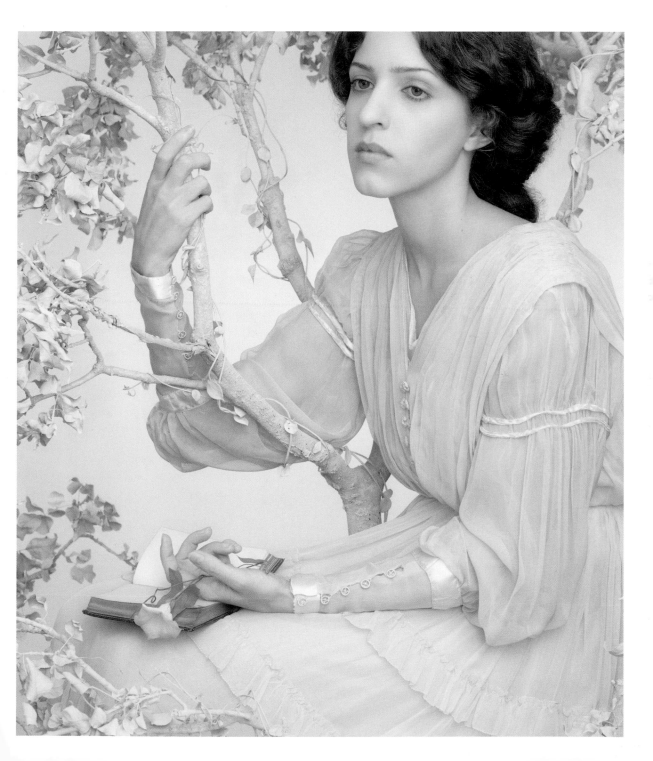

This thing you are holding in your hands right now is the first-ever Booooooom book! It feels really satisfying for me to type that (as it's been a couple years in the making), but I realize you may or may not know what it means. I have no idea if you've been a faithful reader of my art blog since I started Booooooom.com in 2008, or if you just found this book lying on a stack of magazines in someone else's bathroom. Either way, let me explain what you're about to see.

The images in this book are submissions to a project I created called the Remake Project. My interest has always been to inspire and encourage people to make stuff, so I challenged readers of my website to remake a famous work of art as a photo. The idea was to be wildly creative before taking the photo rather than after. I wanted people to build a set, or design a costume, rather than rely on a lot of computer effects. And they did. Hundreds of people submitted work to the Remake Project. When all was said and done, it had been shared by dozens of blogs and major news outlets including *The Huffington Post*, Yahoo! News, msnbc, *The Washington Post*, MoMA, and *Reader's Digest*. *The Guardian* even wrote about it twice. But even more amazing than all the viral attention the project got were the fantastic submissions that came in.

I think the secret to online collaborative art projects is to find the balance between getting lots of people involved and making sure what they create is interesting to look at. If you design a project that has too many steps and too many rules, no one will answer. On the other hand, if you make things too vague and too broad, you'll get lots of submissions, but most of them will have been made by people who were confused or not sure what they were doing, and the end results will appeal to no one.

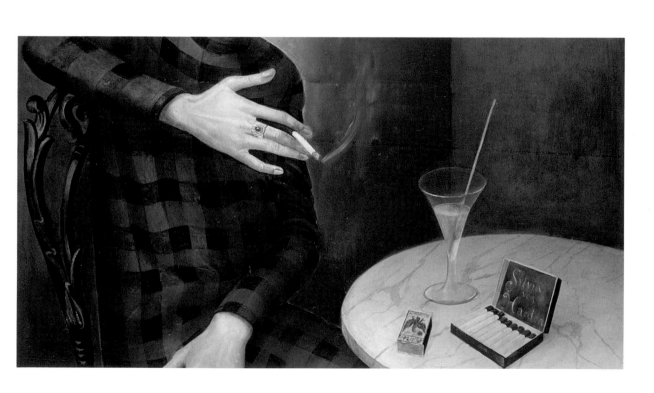

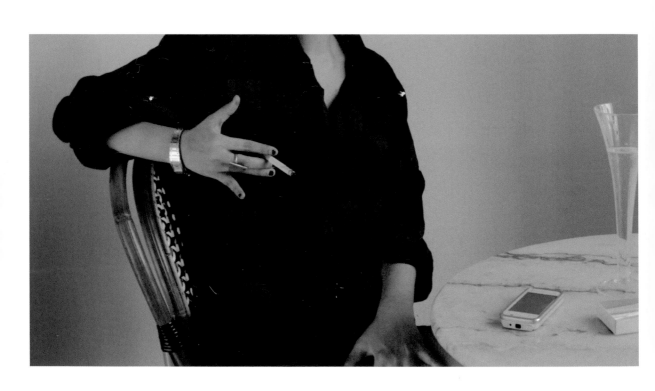

INTRODUCTION

The real beauty of the Remake Project, for me, is that many of the most "amateurish" submissions are my favorites. I put the word amateurish in quotation marks because the idea that there are professional or master remakers is preposterous. What I mean is there's a real honesty to work made by people who aren't practicing artists. Watching a nonartist make art is kind of like watching a child draw— neither one is terribly concerned with the rules of what they "should" be doing, rather they simply embrace the joy of making. When someone is doing something they don't normally do, there's an openness, or even naivety, that is endearing. This is something I'm really interested in, and I think it's one reason this project was successful.

There is a whole spectrum of work represented in this book, from really precise re-creations of works to looser interpretations (some of which may lack a certain level of technical craft but instead possess an energy that in my opinion makes them some of the most interesting pieces in the book).

My only regret is that, because obtaining the rights to famous artworks can be very expensive, we couldn't afford to include every pairing of original artwork and remake that was submitted for the project. If you created original work for the Remake Project and it did not end up in this book, please know that this volume represents just a tiny portion of the submitted work—and everything submitted was fantastic.

Thank you to Chronicle Books for helping me bring this book to life, and huge, huge thanks to Lana Choi, who tirelessly helped me put everything together. I couldn't have done it without you.

I hope you all enjoy this book. Fingers crossed that it's not only the first ever Boooooooom book, but also perhaps the first of many.

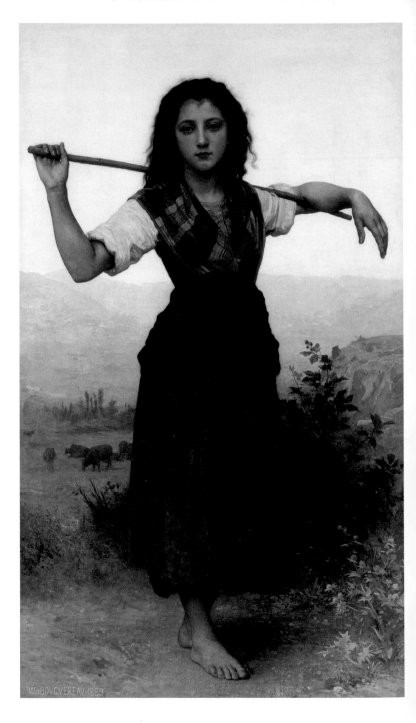

William-Adolphe Bouguereau
The Little Shepherdess 1889 Oil on canvas
Philbrook Museum of Art, Tulsa, OK, USA

THE LITTLE SHEPHERDESS

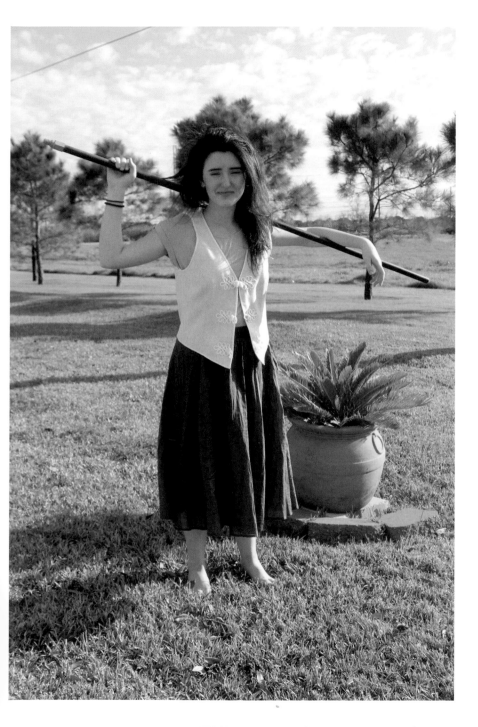

Rafaella Cuneo

THE LITTLE SHEPHERDESS

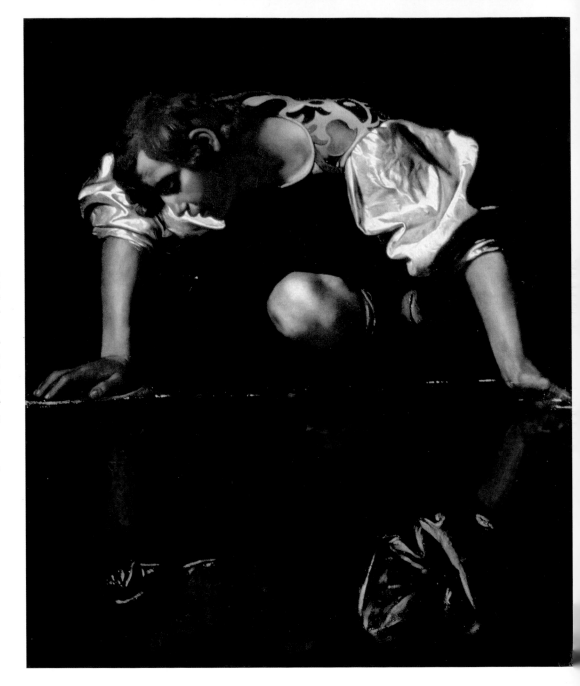

Michelangelo Merisi da Caravaggio
Narcissus c. 1597–99 Oil on canvas
Palazzo Barberini, Rome, Italy

NARCISSUS

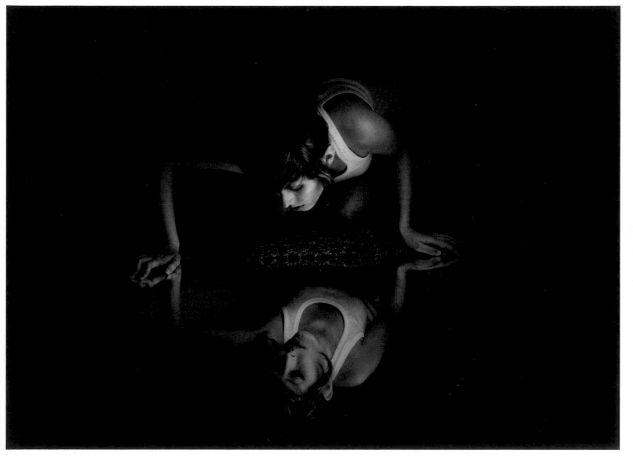

Bernard Arce

NARCISSUS

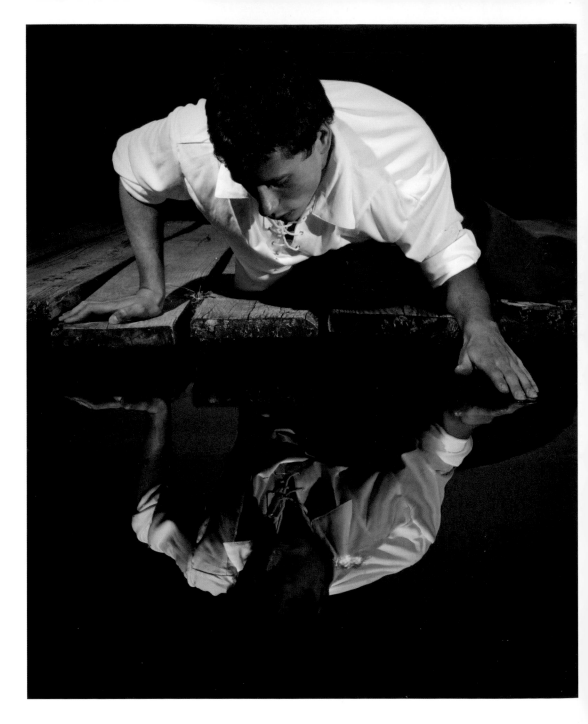

14

NARCISSUS

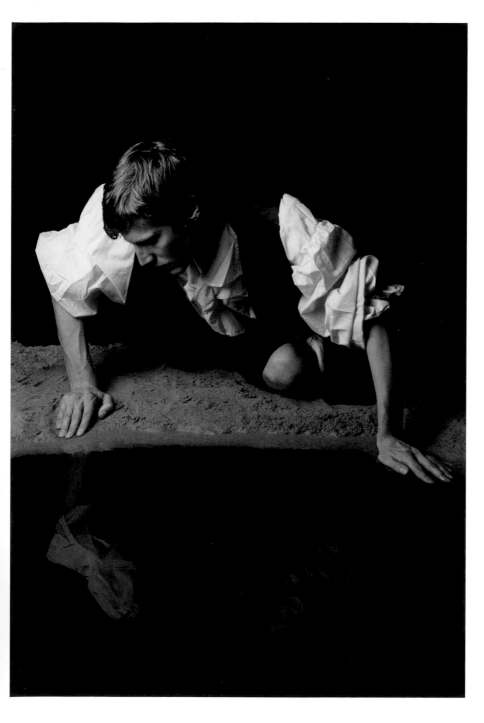

NARCISSUS

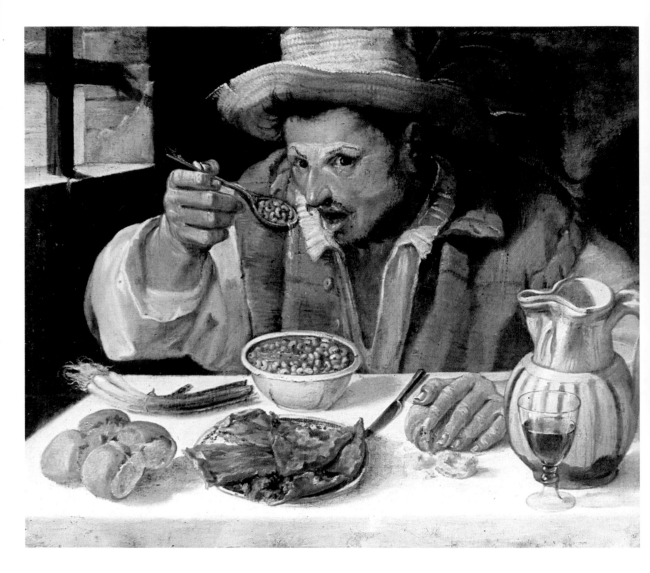

Annibale Carracci
The Bean Eater 1584 Oil on canvas
Galleria Colonna, Rome, Italy

THE BEAN EATER

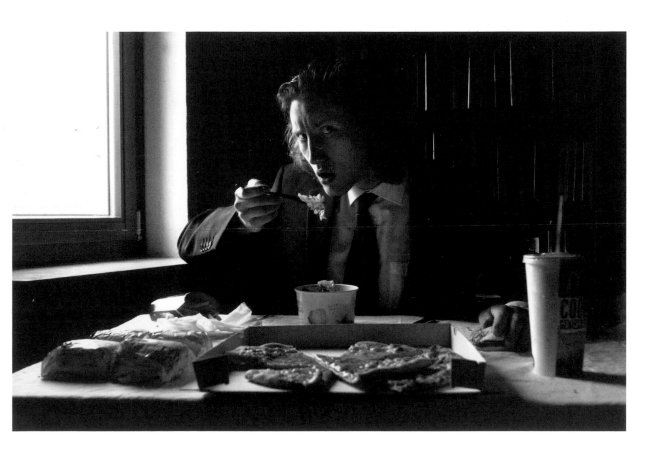

Nicolai Buchner, Morris Peichl, Pia Hettinger, and Peter Dieterich

THE BEAN EATER 17

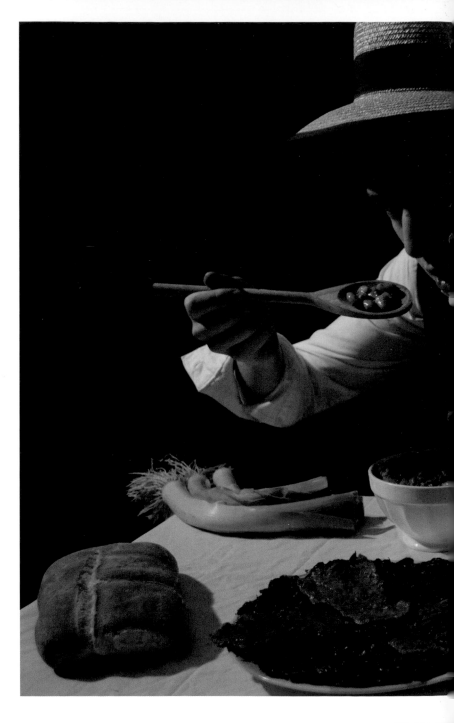

THE B

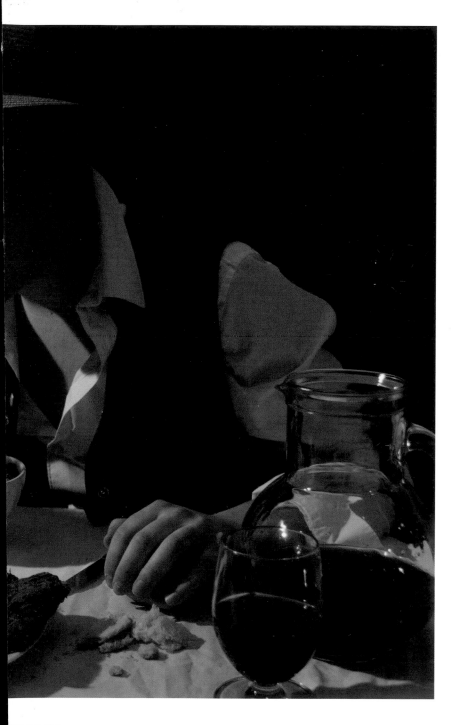

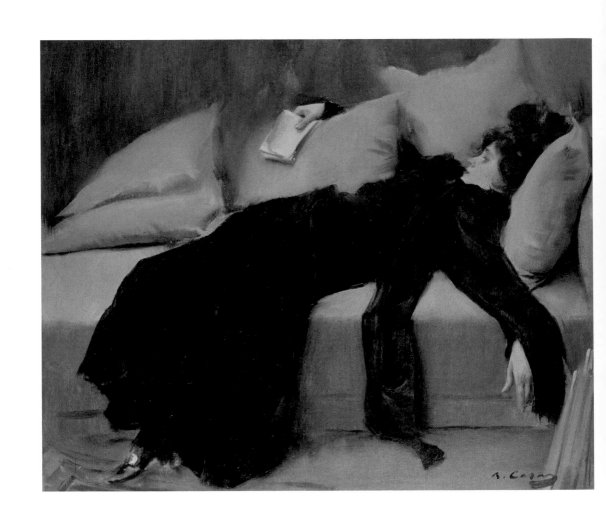

Ramon Casas i Carbó
After the Ball 1895 Oil on canvas
Museu de Montserrat, Abadia de Montserrat, Spain

AFTER THE BALL

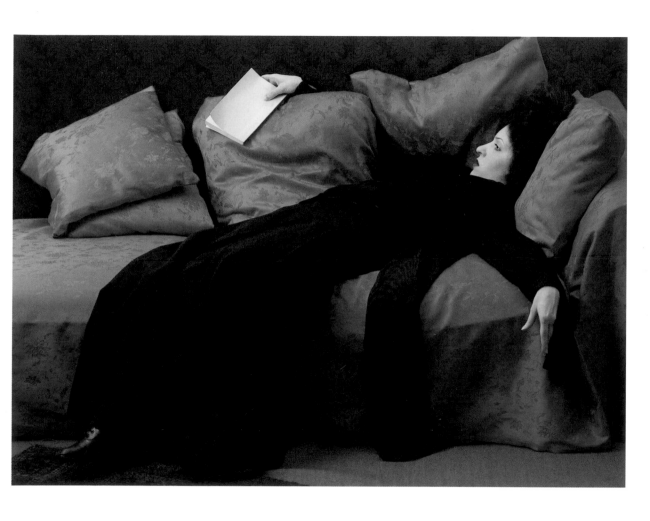

Tania Brassesco and Lazlo Passi Norberto

AFTER THE BALL 21

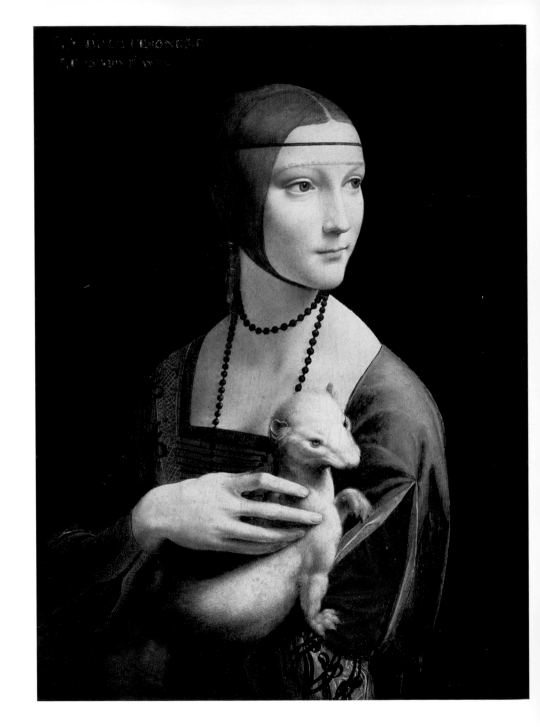

Leonardo da Vinci
The Lady with the Ermine (Cecilia Gallerani) 1496 Oil on walnut panel
Czartoryski Museum, Cracow, Poland

THE LADY WITH THE ERMINE

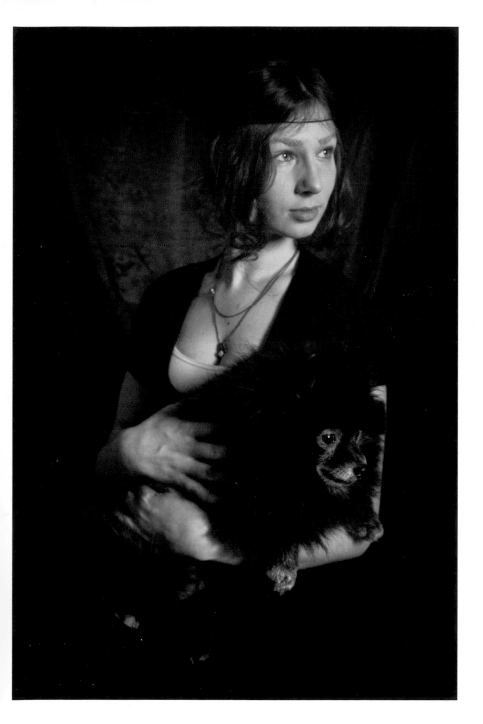

Jessica Wood

THE LADY WITH THE ERMINE

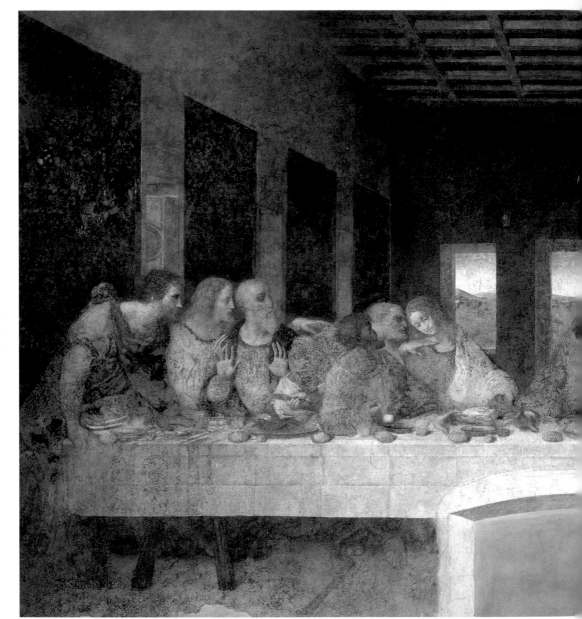

Leonardo da Vinci
The Last Supper 1495–97 Fresco (post-restoration)
Santa Maria delle Grazie, Milan, Italy

THE L

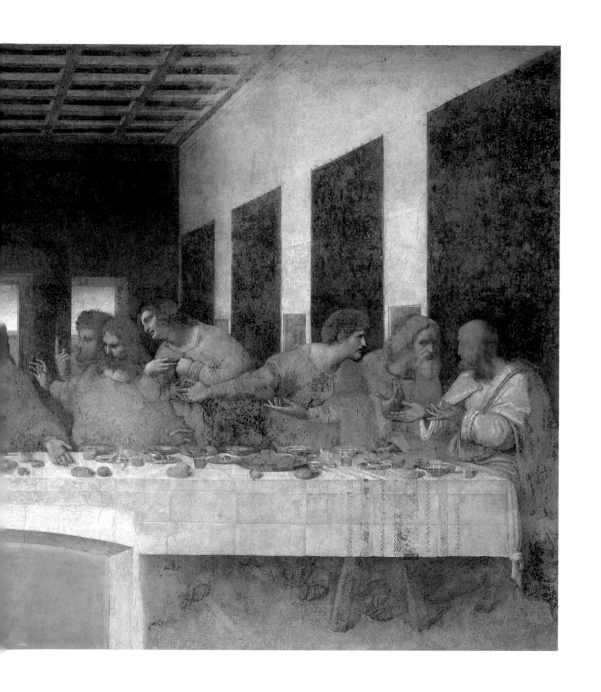

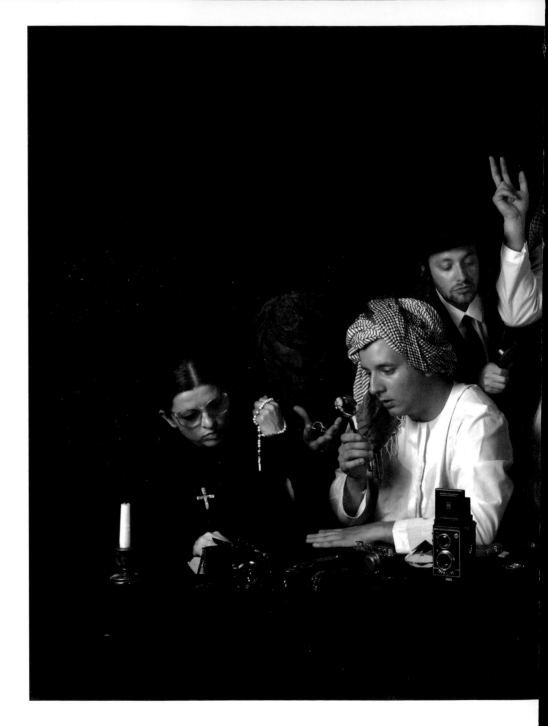

THE L

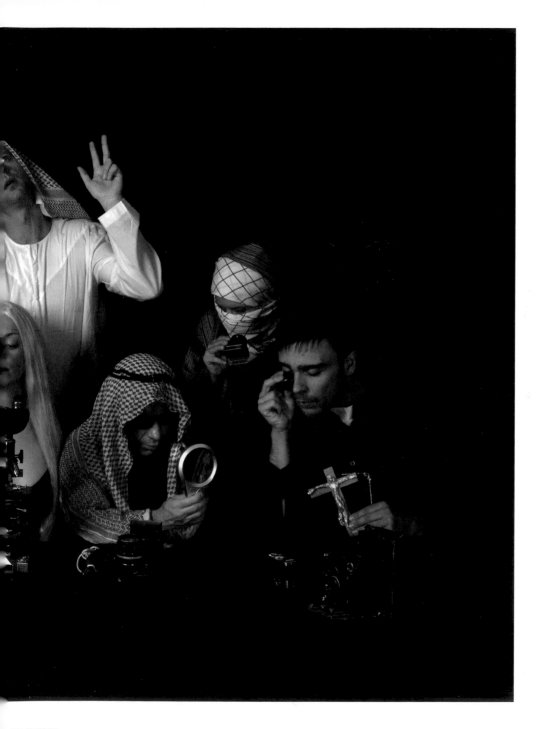

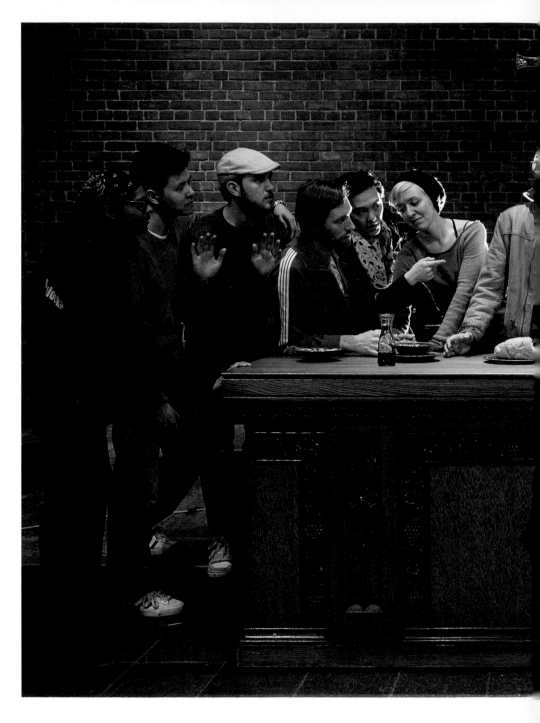

THE L

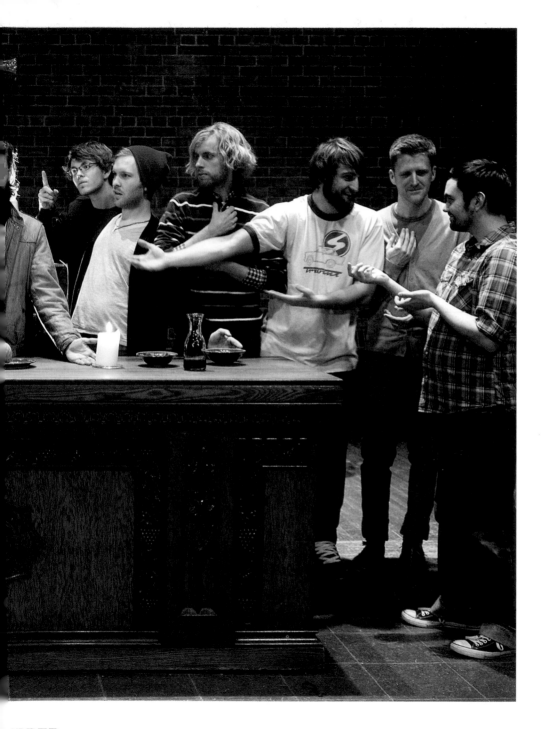

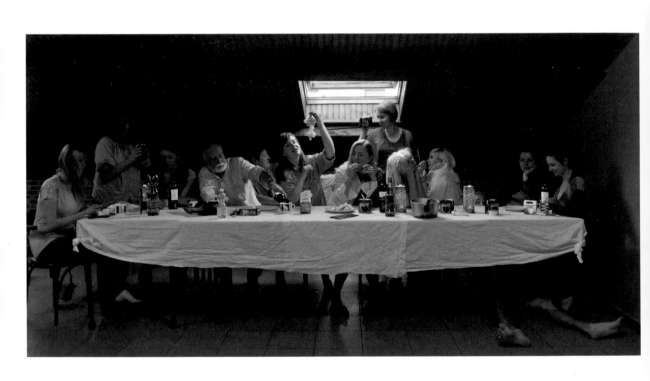

Agata Materowicz

THE LAST SUPPER

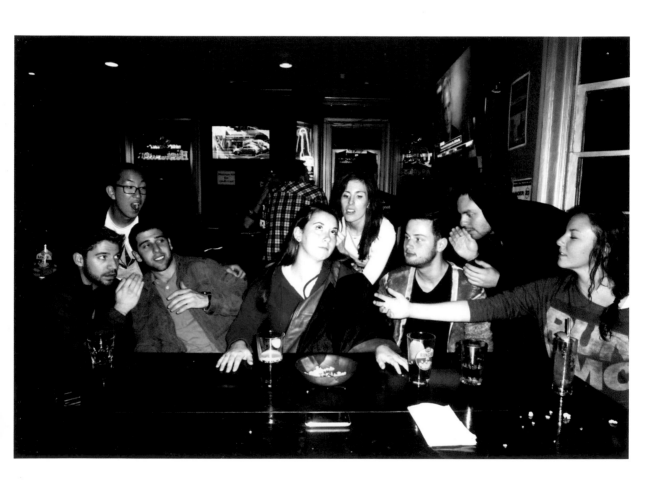

Lucy Sole

THE LAST SUPPER

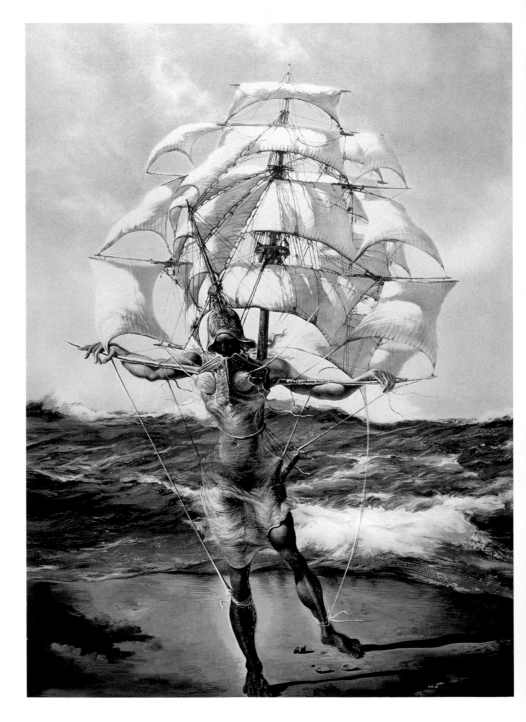

Salvador Dali
Costume for "Tristan Insane," The Ship 1942–43 Watercolor on paper
Salvador Dali Museum, St. Petersburg, FL. USA

THE SHIP

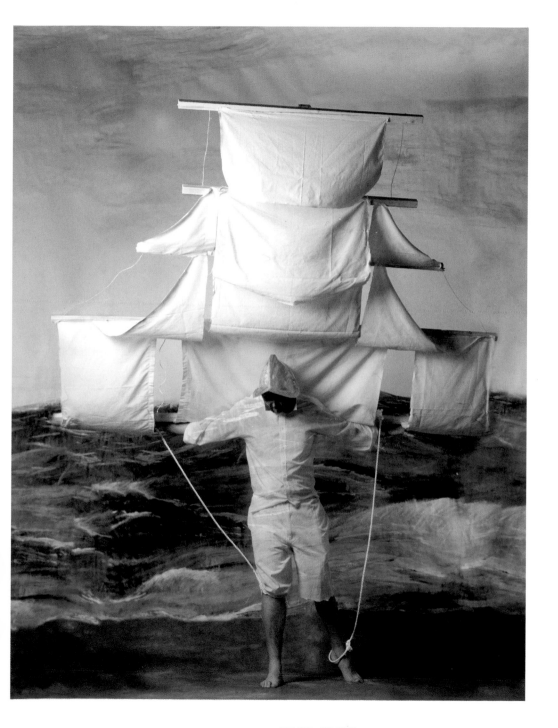

THE SHIP

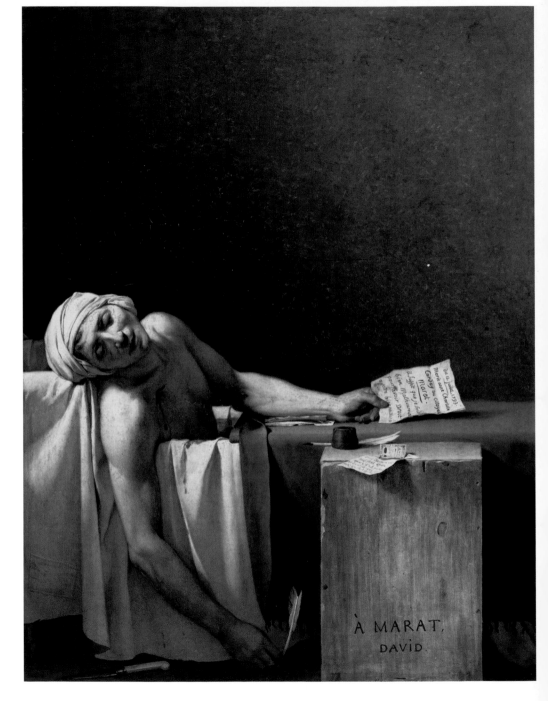

Jacques Louis David
The Death of Marat 1793 Oil on canvas
Musées Royaux des Beaux-Arts de Belgique, Brussels, Belgium

THE DEATH OF MARAT

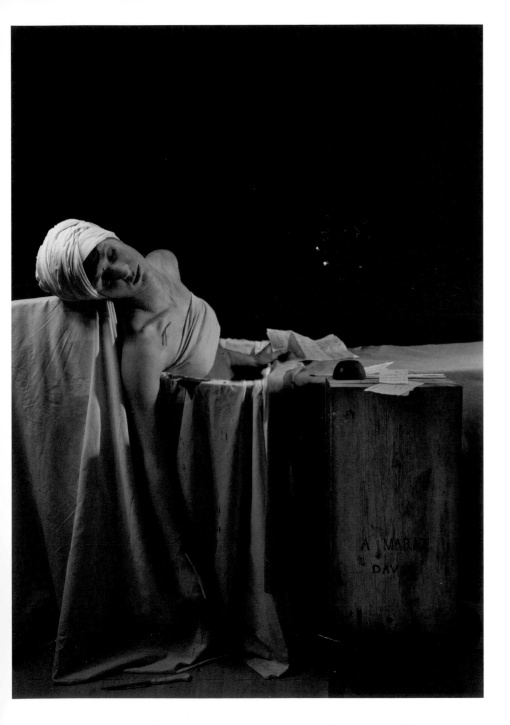

THE DEATH OF MARAT

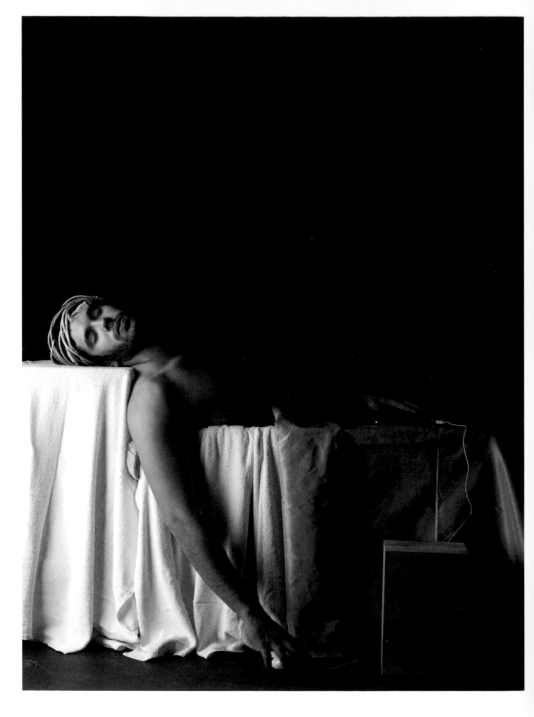

THE DEATH OF MARAT

Bruna Pelissari

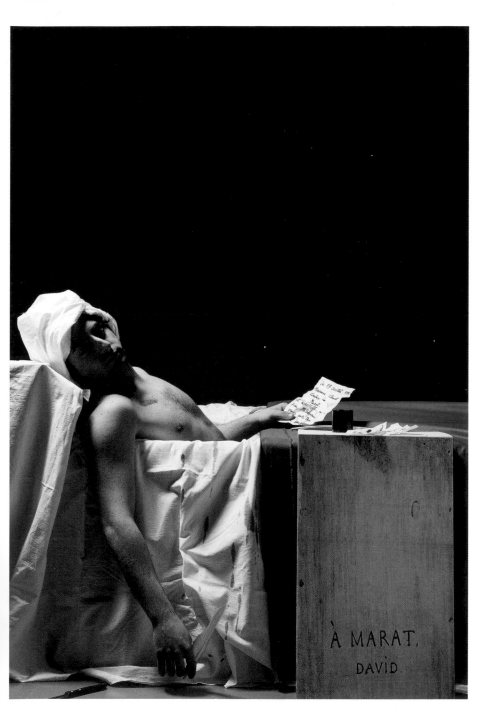

Matteo Bandiello

THE DEATH OF MARAT

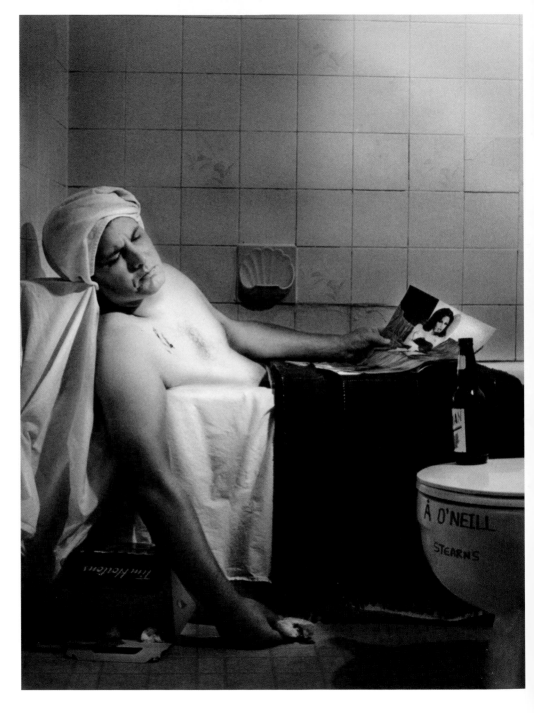

Jeff Chiba Stearns

THE DEATH OF MARAT

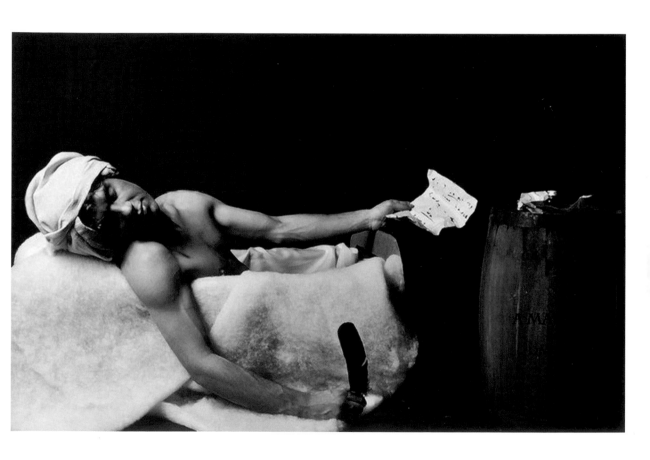

Rebekah Alviani

THE DEATH OF MARAT 39

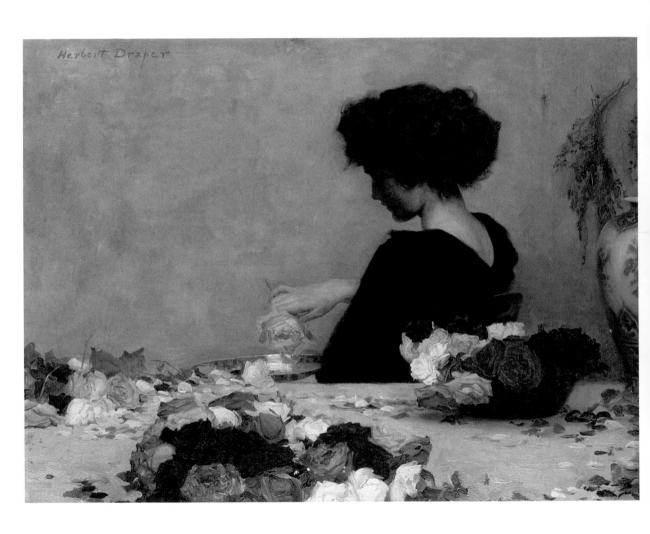

Herbert James Draper
Pot Pourri 1897 Oil on canvas
Private collection

POT POURRI

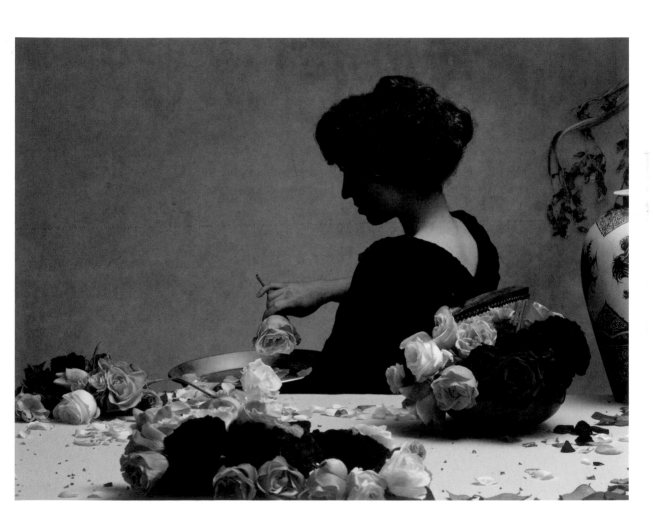

Tania Brassesco and Lazlo Passi Norberto

POT POURRI 41

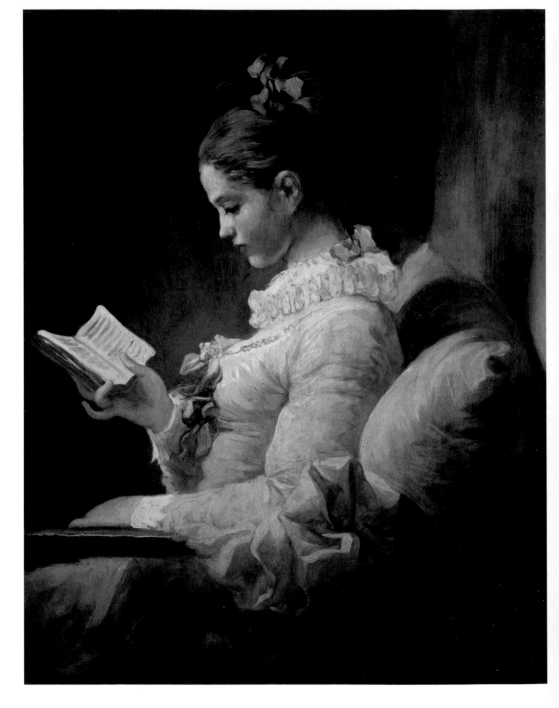

Jean-Honoré Fragonard
Young Girl Reading c. 1770 Oil on canvas
National Gallery of Art, Washington, DC, USA

YOUNG GIRL READING

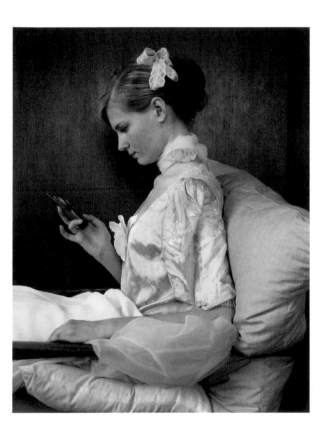

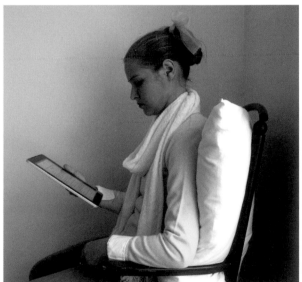

left: Sona Brabencova;
right: Lisa Reynolds and Dana Reynolds

YOUNG GIRL READING 43

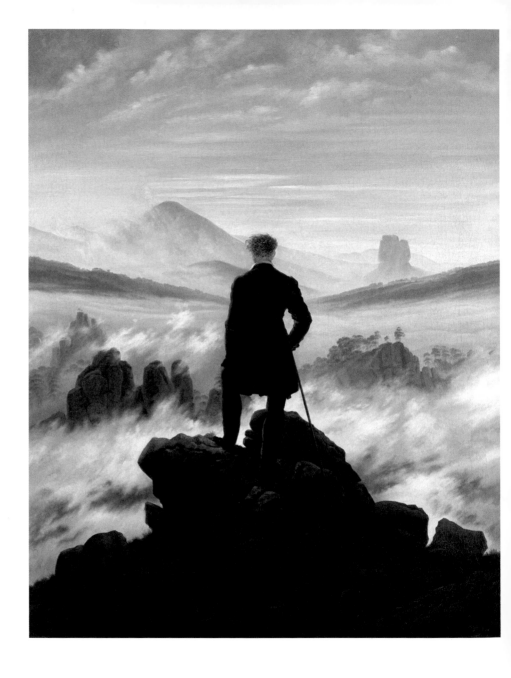

THE WANDERER ABOVE THE SEA OF FOG

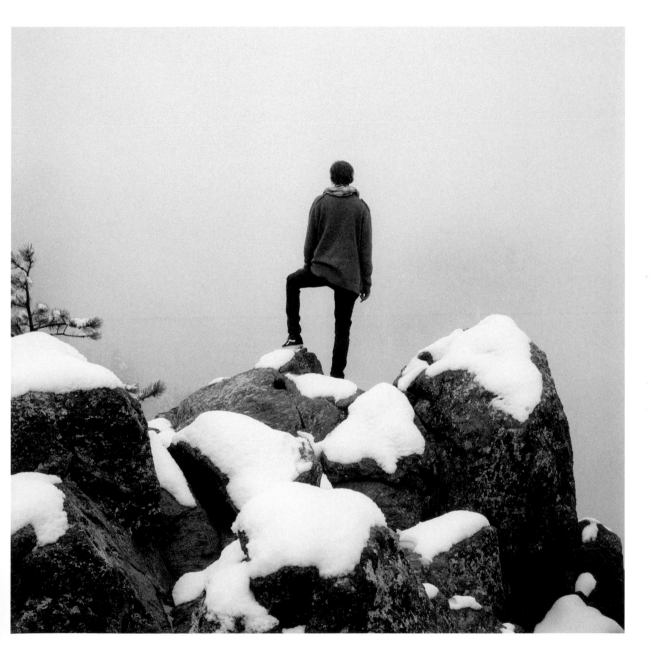

Spencer Harding

THE WANDERER ABOVE THE SEA OF FOG 45

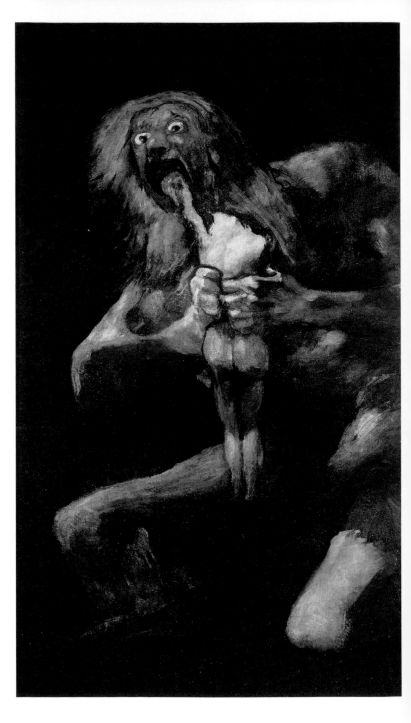

Francisco José de Goya y Lucientes
Saturn Devouring One of His Sons 1821–23 Mural transferred to canvas
Museo Nacional del Prado, Madrid, Spain

SATURN DEVOURING ONE OF HIS SONS

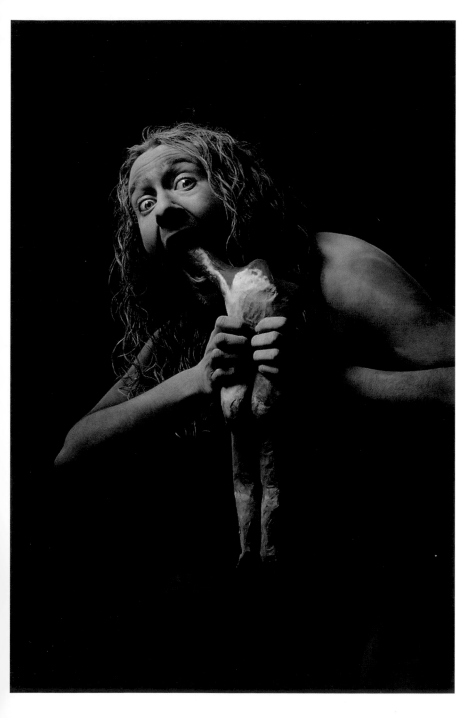

Robert Flynn

SATURN DEVOURING ONE OF HIS SONS

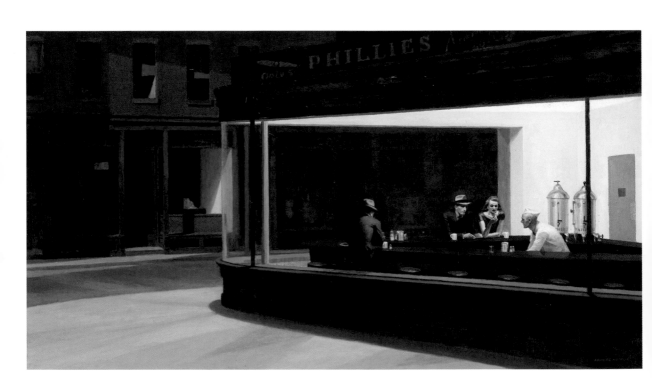

Edward Hopper
Nighthawks 1942 Oil on canvas
Friends of American Art Collection, The Art Institute of Chicago, Chicago, IL, USA

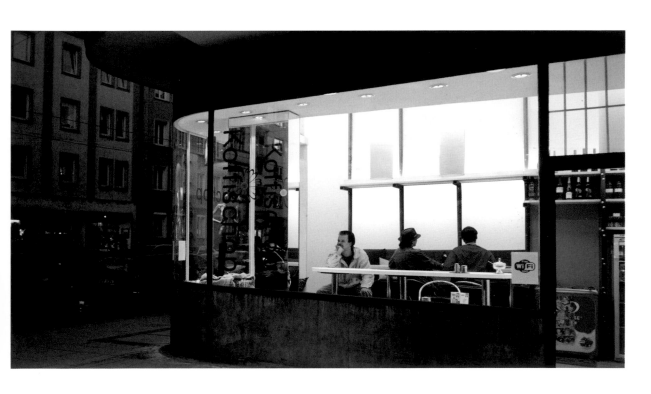

Bastian Vice and Jiji Seabird

NIGHTHAWKS 49

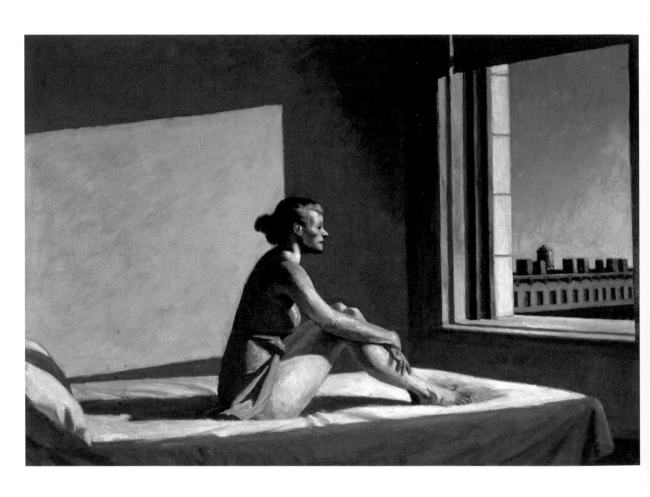

Edward Hopper
Morning Sun 1952 Oil on canvas
Columbus Museum of Art, Columbus, OH, USA

MORNING SUN

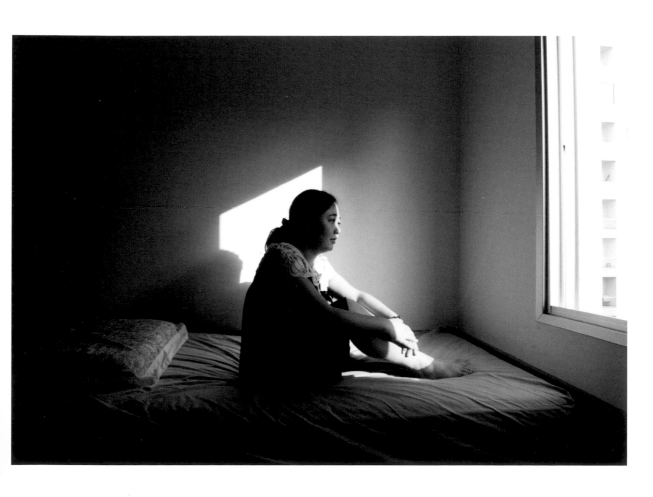

Ester Chuang

MORNING SUN

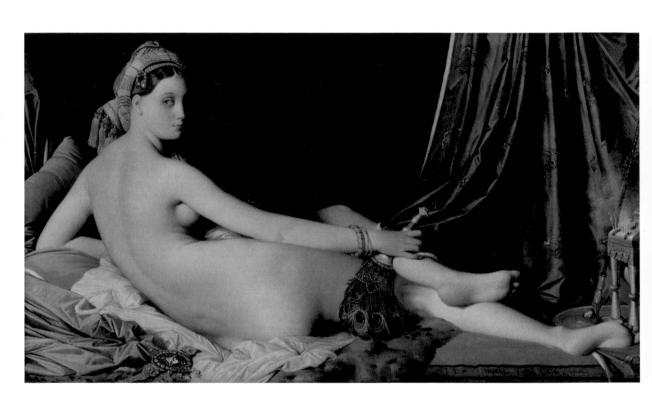

Jean-Auguste-Dominique Ingres
The Grand Odalisque 1814 Oil on canvas
Louvre, Paris, France

THE GRAND ODALISQUE

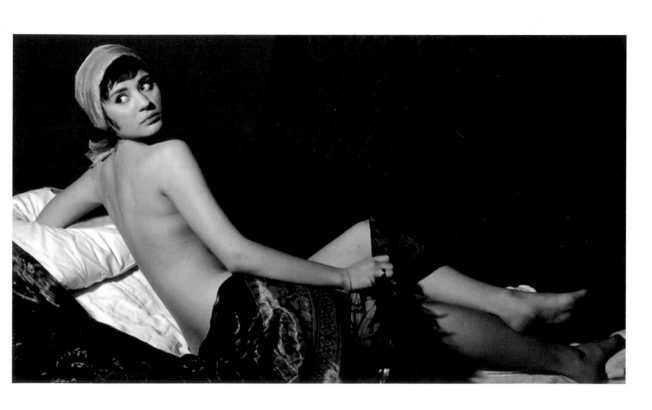

Rebekah Alviani

THE GRAND ODALISQUE 53

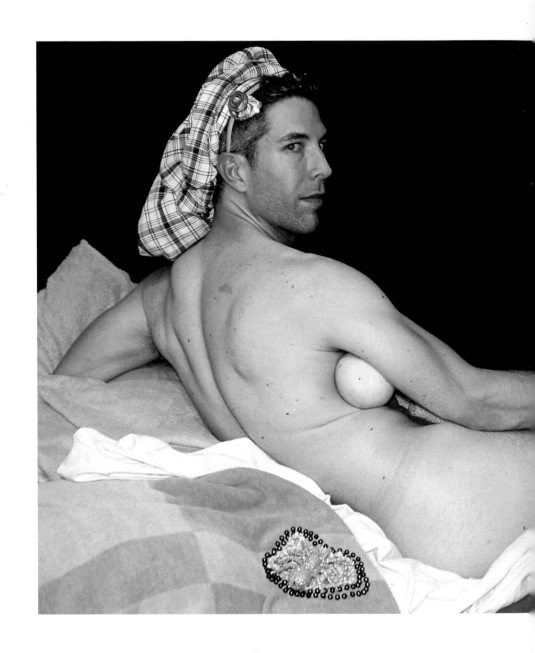

54

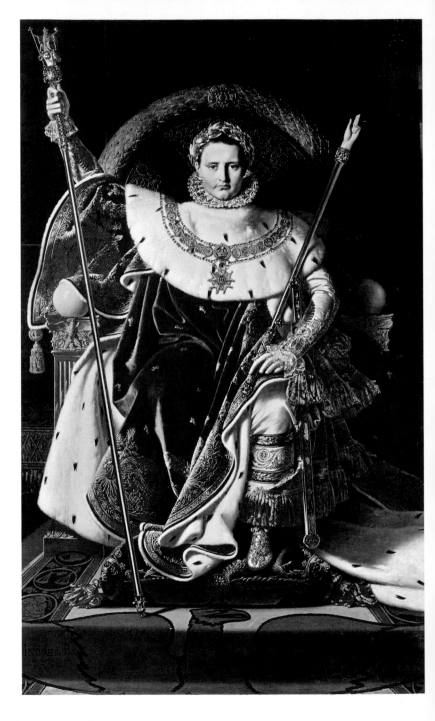

Jean-Auguste-Dominique Ingres
Napoleon I (1769–1821) on the Imperial Throne 1806 Oil on canvas
Musée de l'Armée, Paris, France

NAPOLEON I (1769–1821) ON THE IMPERIAL THRONE

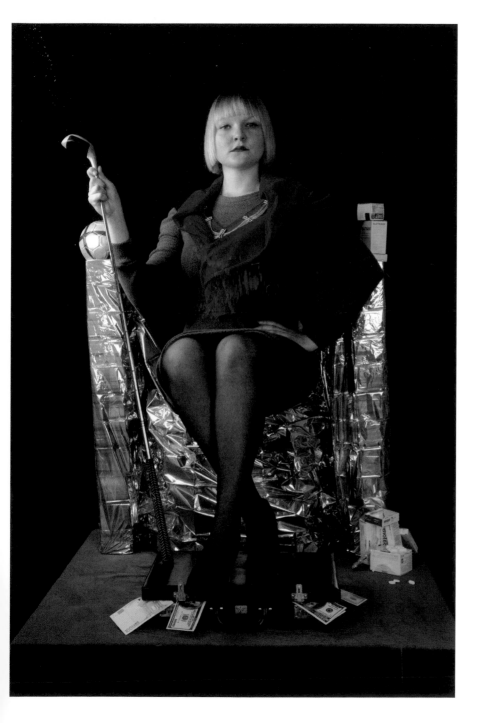

NAPOLEON I (1769–1821) ON THE IMPERIAL THRONE 57

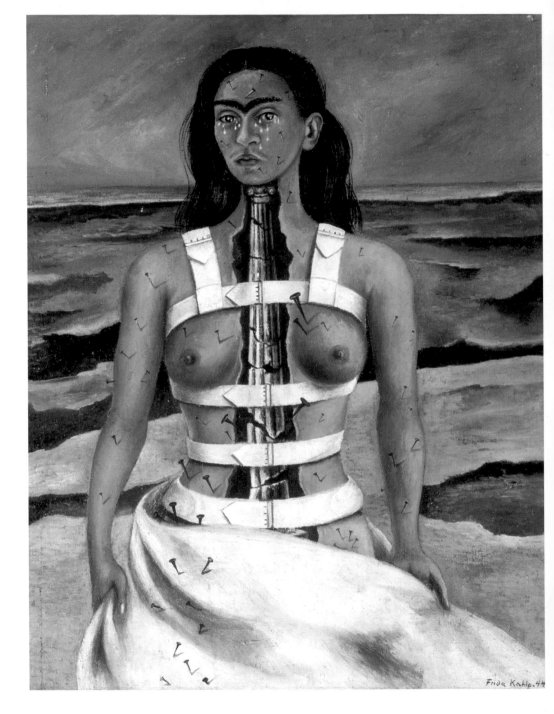

Frida Kahlo
The Broken Column 1944 Oil on canvas
Fundación Dolores Olmedo, Mexico City, Mexico

THE BROKEN COLUMN

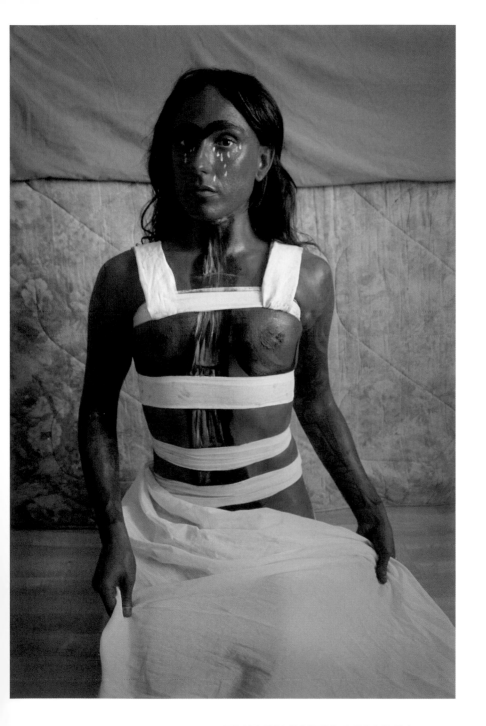

THE BROKEN COLUMN

59

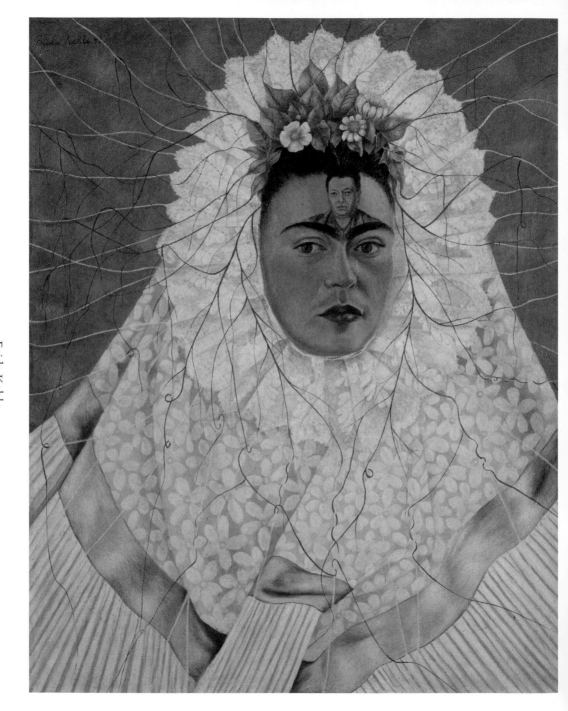

Frida Kahlo
Self-Portrait as Tehuana or Diego in My Mind 1943 Oil on Masonite
The Jacques and Natasha Gelman Collection of 20th Century Mexican Art and the
Vergel Foundation, Mexico City, Mexico

SELF-PORTRAIT AS TEHUANA

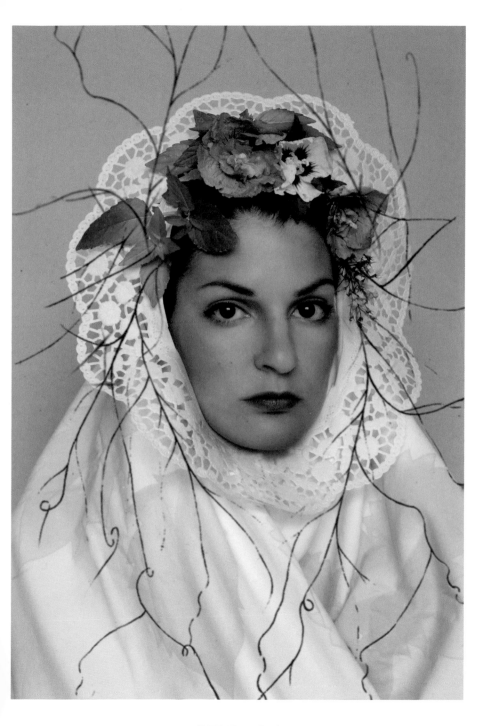

Tamara Eda Temucin

SELF-PORTRAIT AS TEHUANA

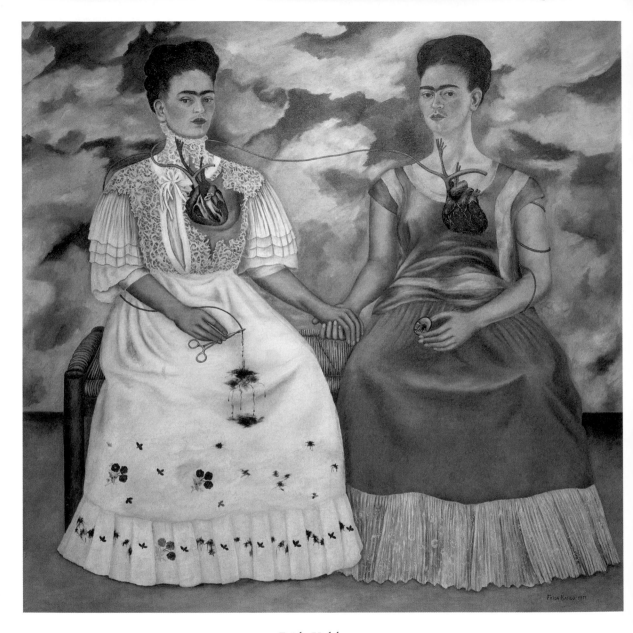

Frida Kahlo
The Two Fridas 1939 Oil on canvas
Museo de Arte Moderno, Mexico City, Mexico

THE TWO FRIDAS

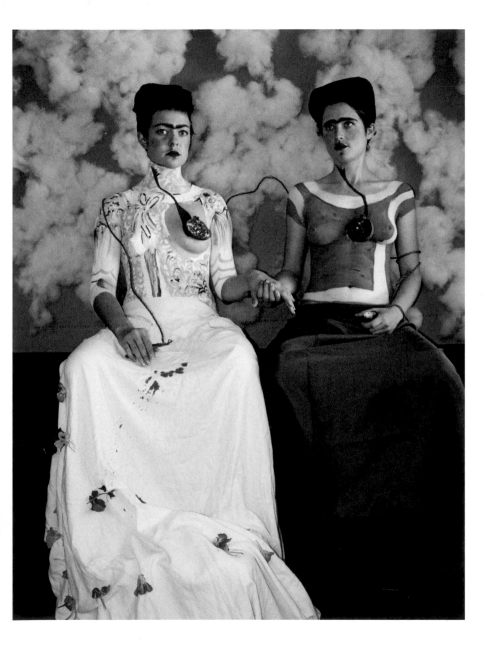

THE TWO FRIDAS

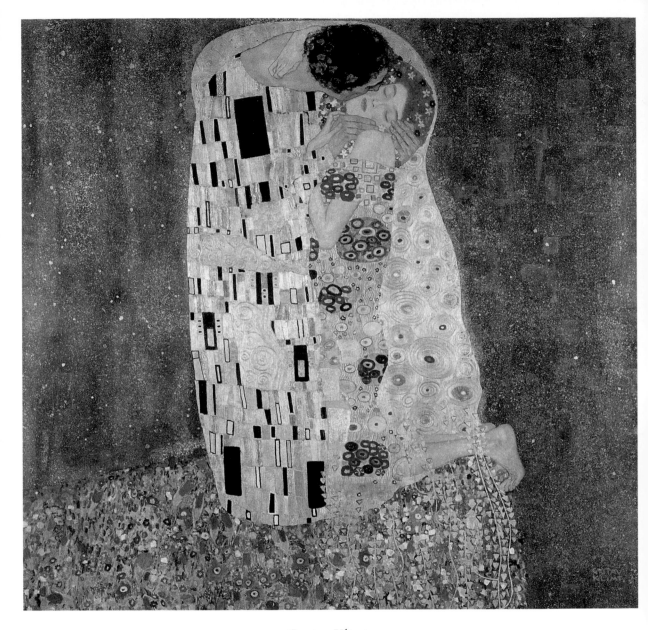

Gustav Klimt
The Kiss　1907–08　Oil on canvas
Österreichische Galerie Belvedere, Vienna, Austria

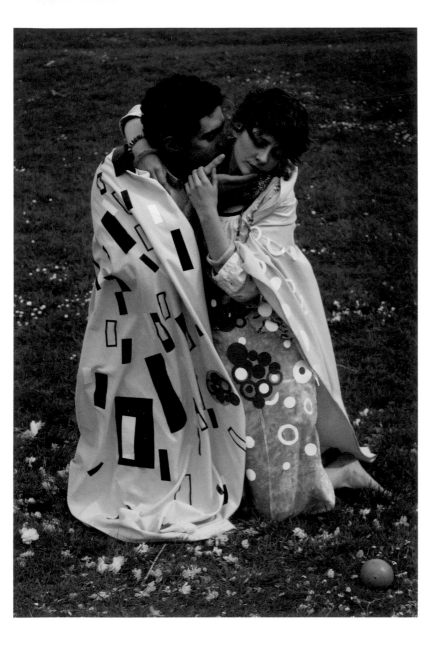

Sybille de Chavagnac, Floriane Jacques, and Cécile Bourrellis

THE KISS

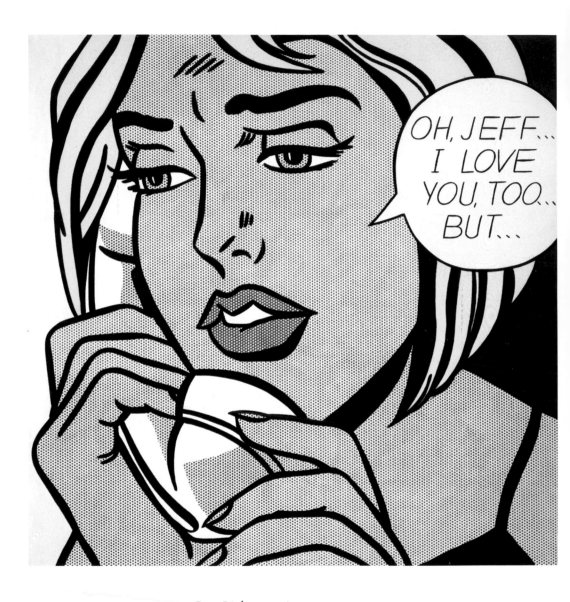

Roy Lichtenstein
Oh, Jeff... I Love You, Too... But... 1964 Oil and magna on canvas
Private collection

OH, JEFF... I LOVE YOU, TOO... BUT...

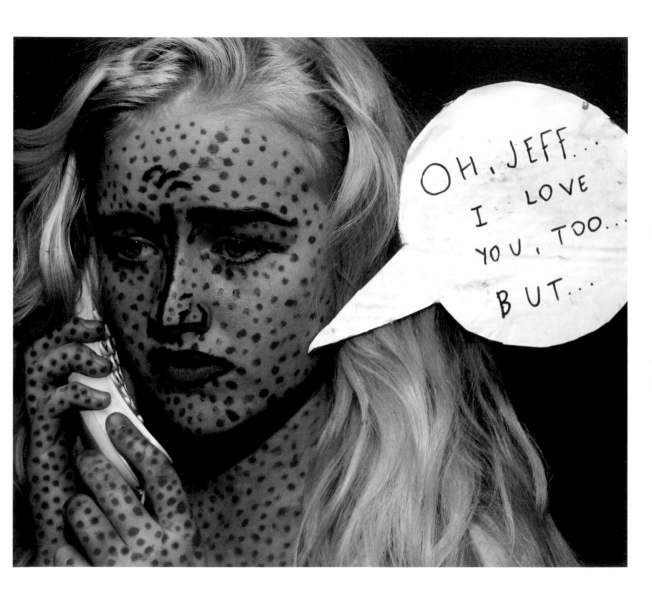

Hadar Ben-Simon

OH, JEFF . . . I LOVE YOU, TOO . . . BUT . . . 67

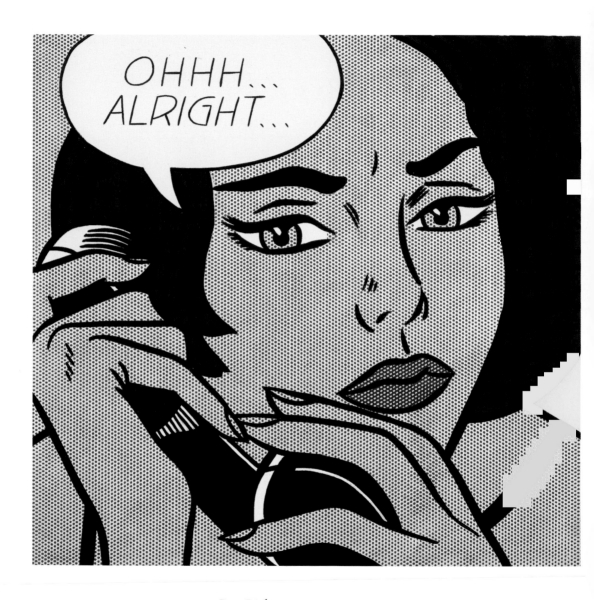

Roy Lichtenstein
Ohhh…Alright… 1964 Oil and magna on canvas
Private collection

OHHH… ALRIGHT…

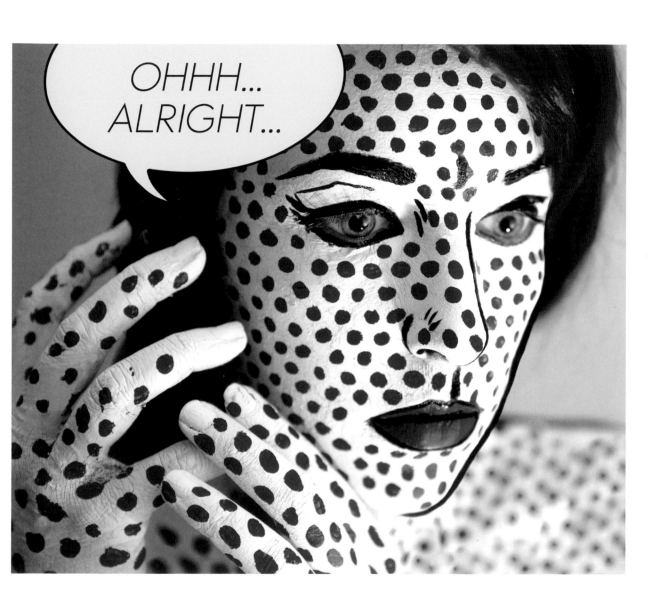

Emily Kiel

OHHH… ALRIGHT… 69

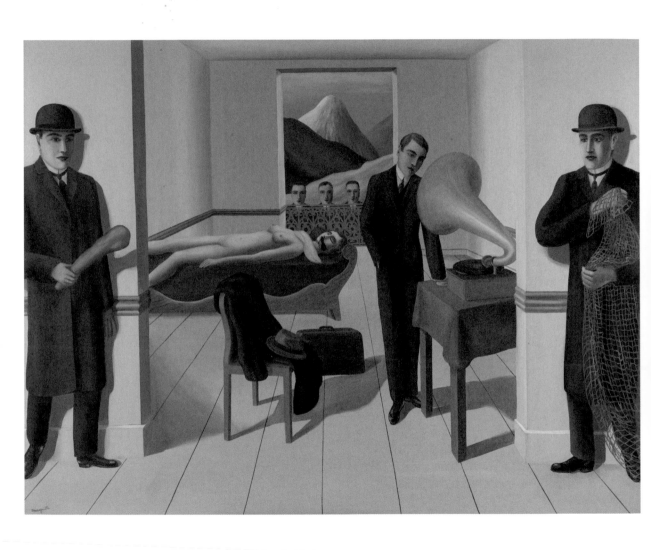

René Magritte
The Menaced Assassin 1927 Oil on canvas
The Museum of Modern Art, New York, NY, USA

THE MENACED ASSASSIN

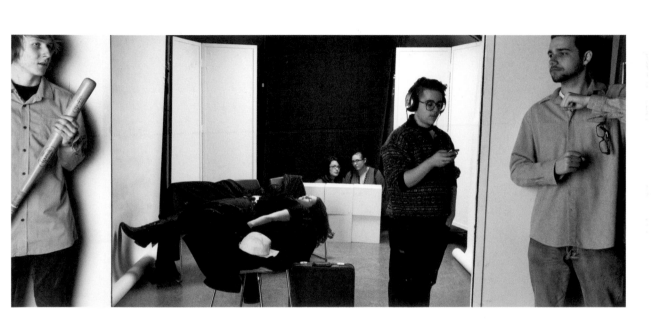

Guillaume Barbeau

THE MENACED ASSASSIN 71

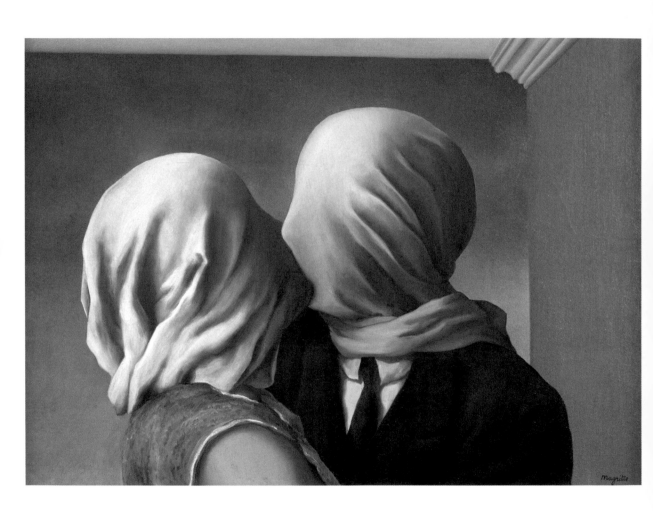

René Magritte
The Lovers 1928 Oil on canvas
The Museum of Modern Art, New York, NY, USA

THE LOVERS

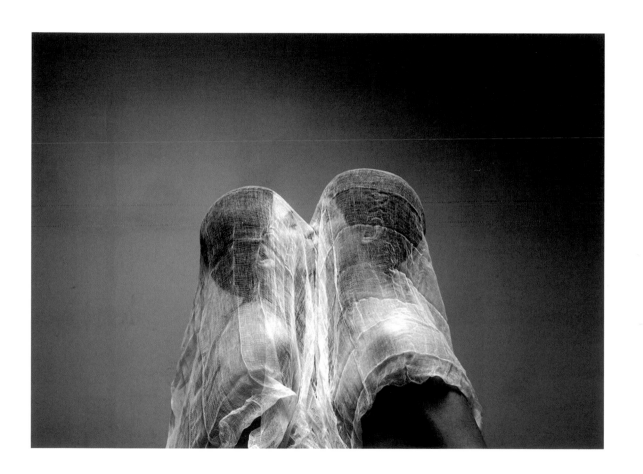

Linda Cieniawska

THE LOVERS

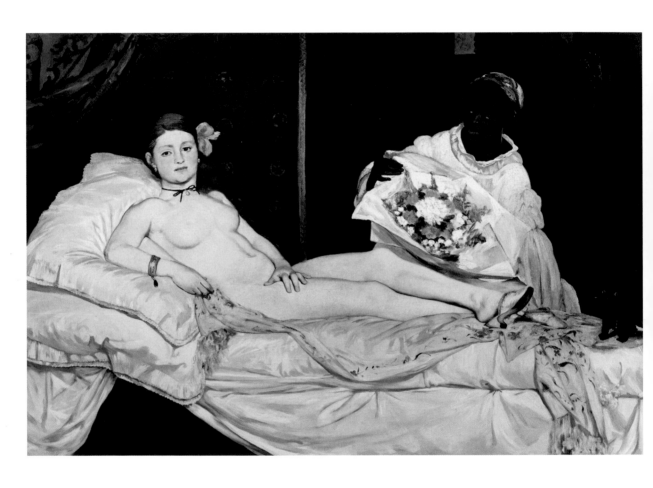

Édouard Manet
Olympia 1863 Oil on canvas
Musée d'Orsay, Paris, France

OLYMPIA

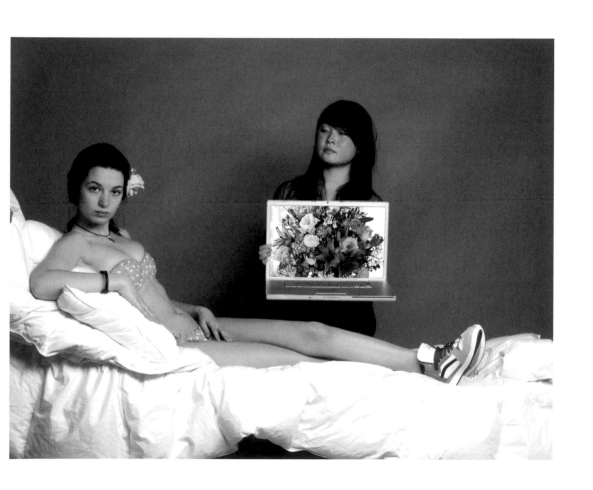

Bruna Pelissari

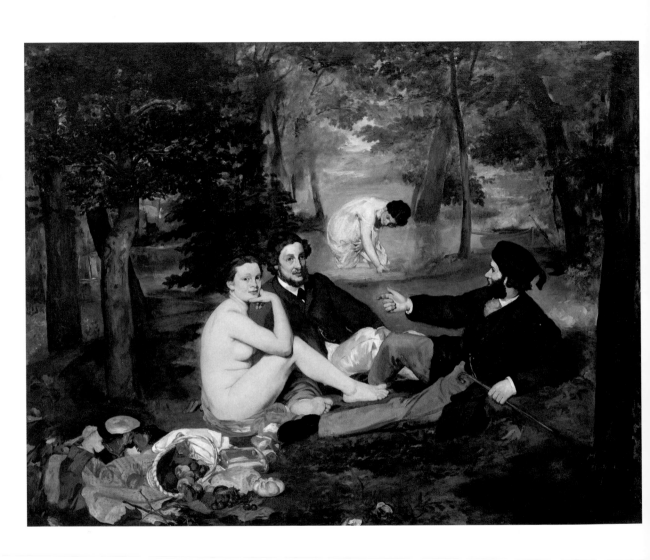

Édouard Manet
Le Déjeuner sur l'Herbe (Luncheon on the Grass) 1863 Oil on canvas
Musée d'Orsay, Paris, France

LUNCHEON ON THE GRASS

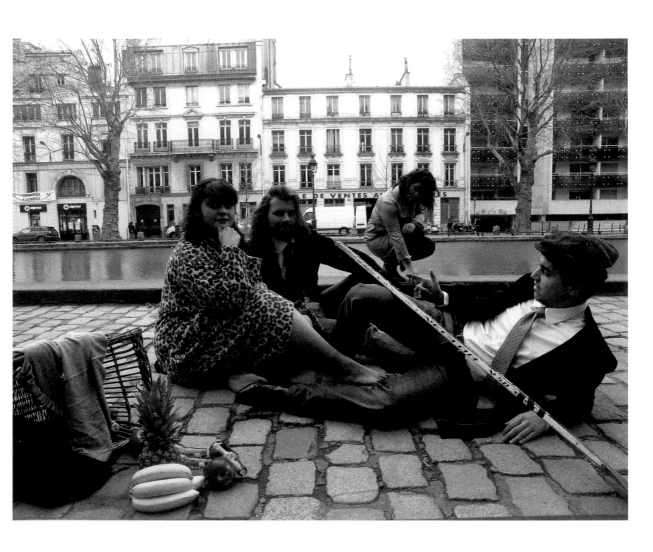

Gizem Karakaş

LUNCHEON ON THE GRASS 77

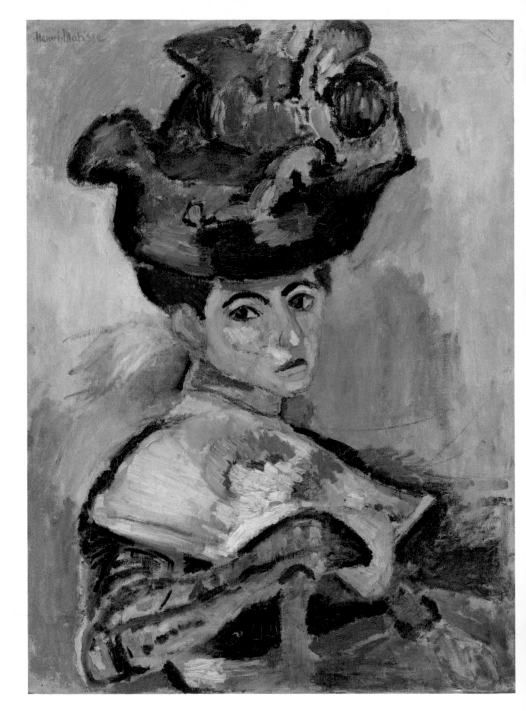

WOMAN WITH A HAT

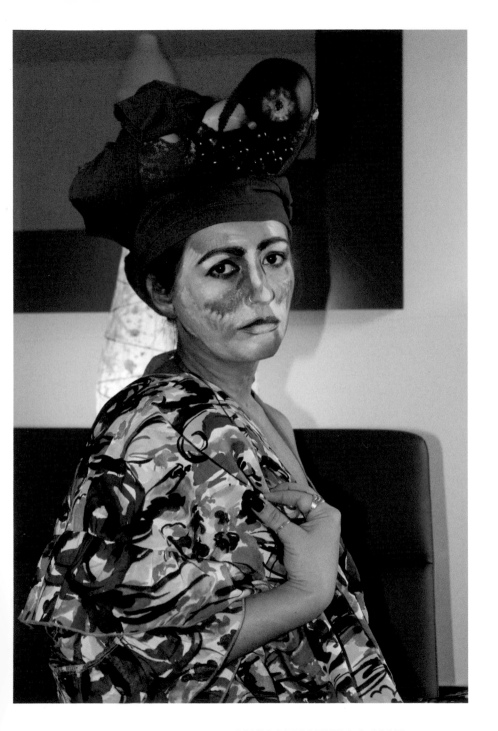

Stella Vula

WOMAN WITH A HAT

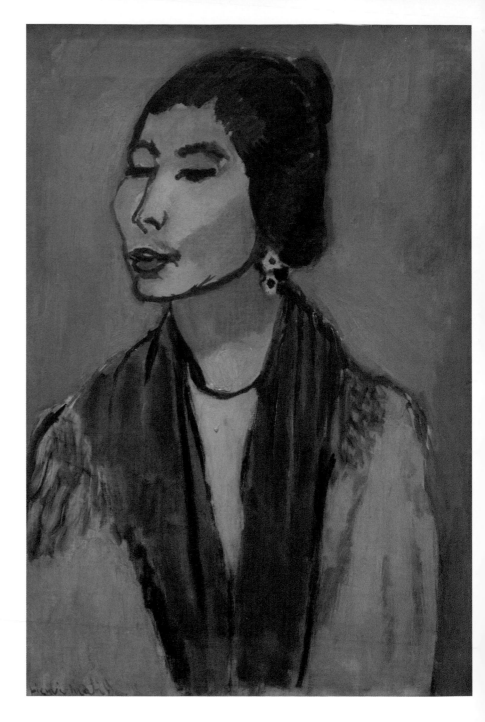

Henri Matisse
Joaquina 1910–11 Oil on canvas
National Gallery, Prague, Czech Republic

JOAQUINA

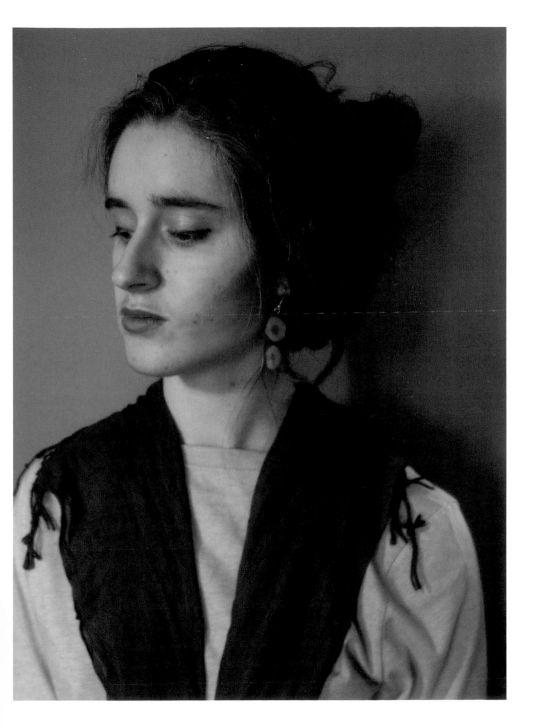

JOAQUINA

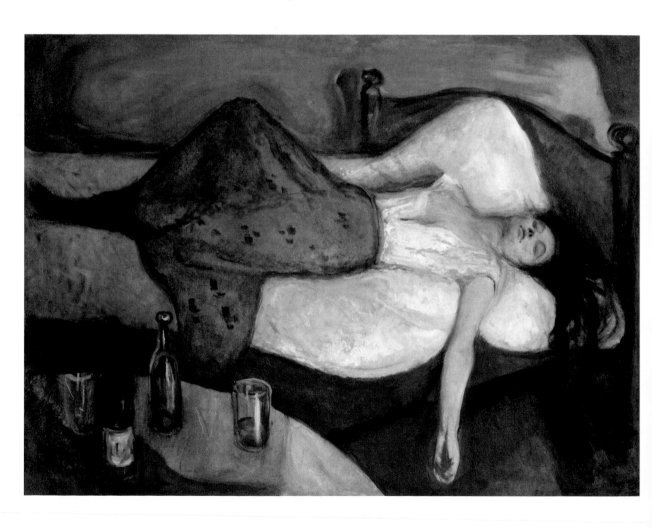

Edvard Munch
The Day After 1894 Oil on canvas
National Gallery, Oslo, Norway

THE DAY AFTER

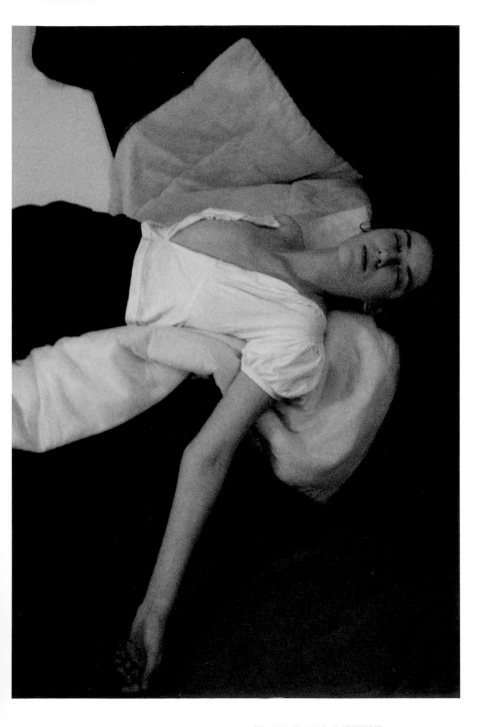

THE DAY AFTER

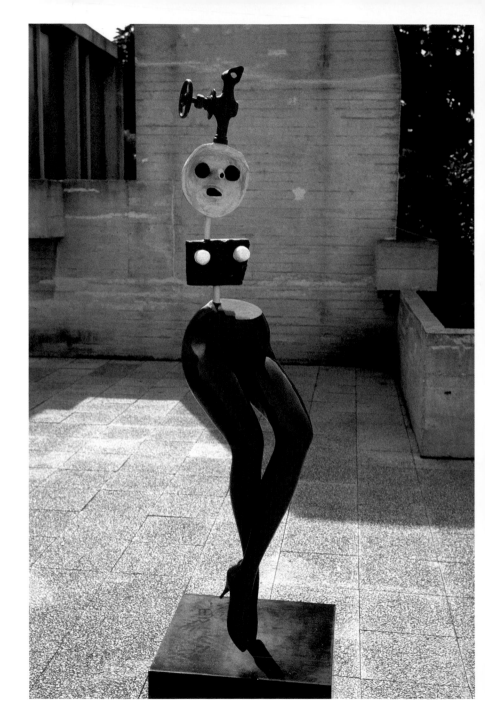

Joan Miró
Jeune Fille S'Evadant/Muchacha Evadiendose (Young Woman Escaping) 1967 Painted bronze
Fundació Joan Miró, Barcelona, Spain

YOUNG WOMAN ESCAPING

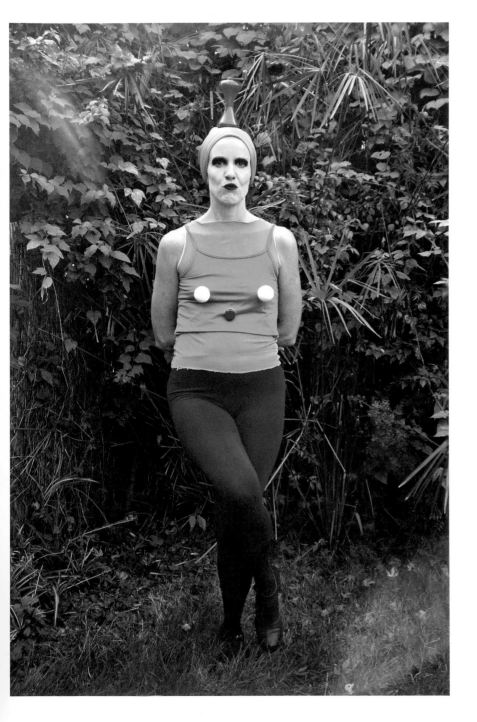

Alma Larroca and ED

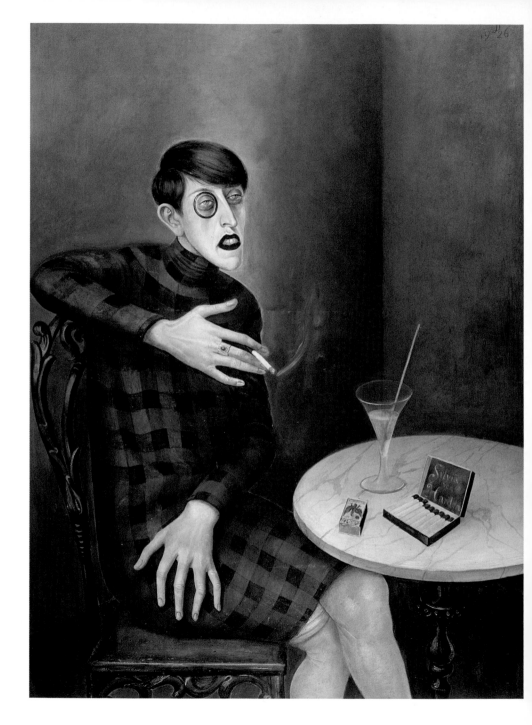

Otto Dix
Portrait of the Journalist Sylvia Von Harden (1894–1963) 1926 Mixed media on panel
Musée National d'Art Moderne, Centre Pompidou, Paris, France

PORTRAIT OF THE JOURNALIST SYLVIA VON HARDEN

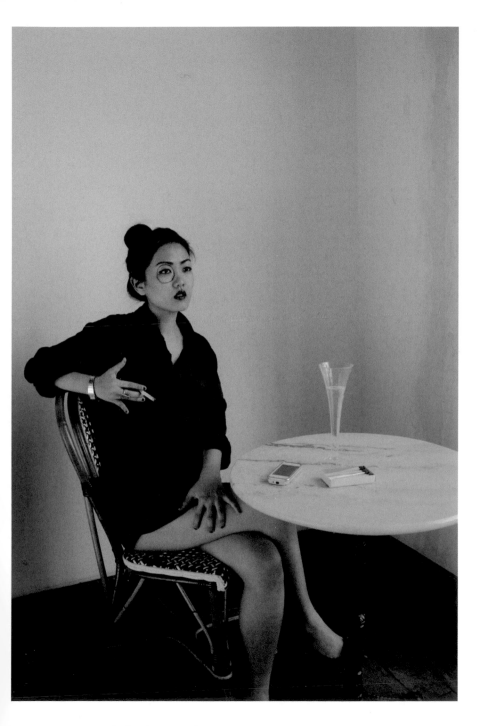

Stephan Hofmann and So-Yeon Kim

PORTRAIT OF THE JOURNALIST SYLVIA VON HARDEN 87

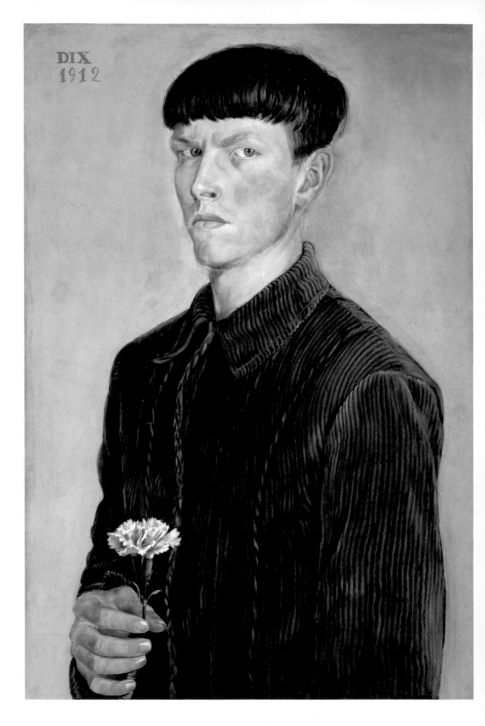

Otto Dix
Self-Portrait 1912 Oil on tempera on panel
Detroit Institute of Arts, Detroit, MI, USA

SELF-PORTRAIT

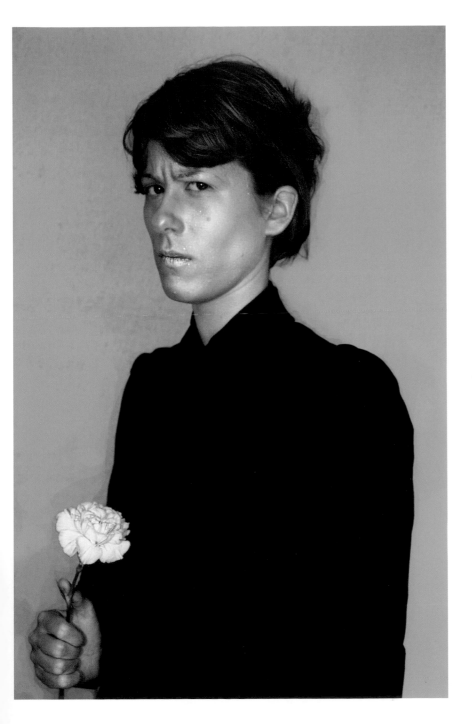

SELF-PORTRAIT

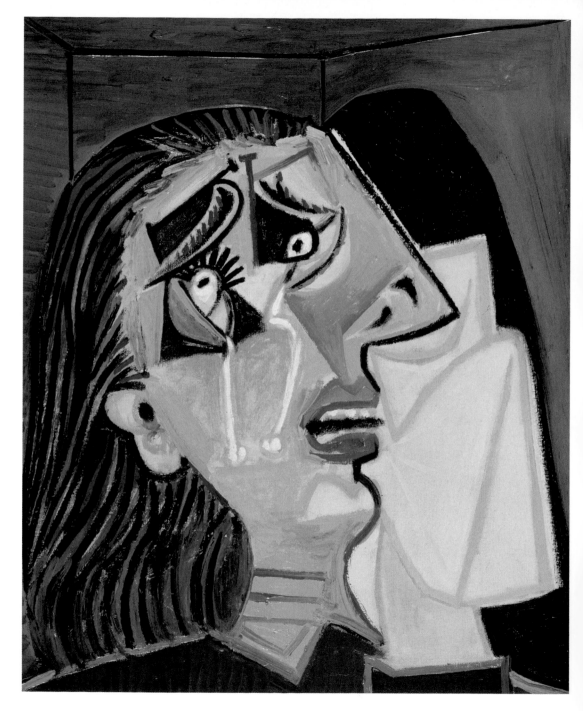

Pablo Picasso
Weeping Woman 1937 Oil on canvas
National Gallery of Victoria, Melbourne, Australia

WEEPING WOMAN

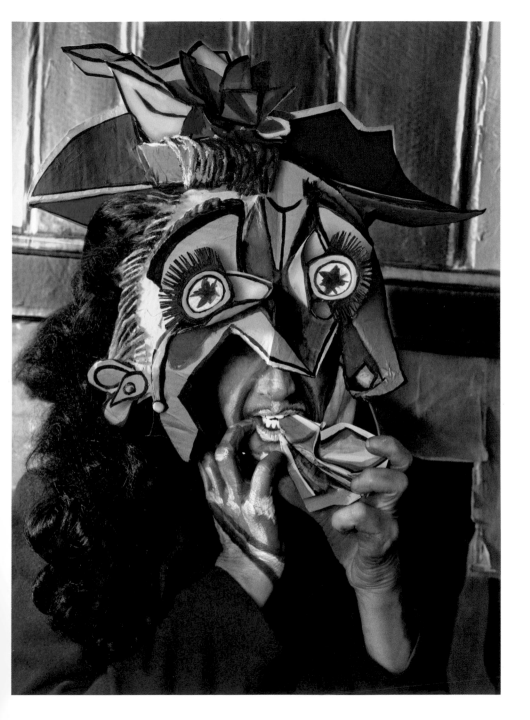

WEEPING WOMAN

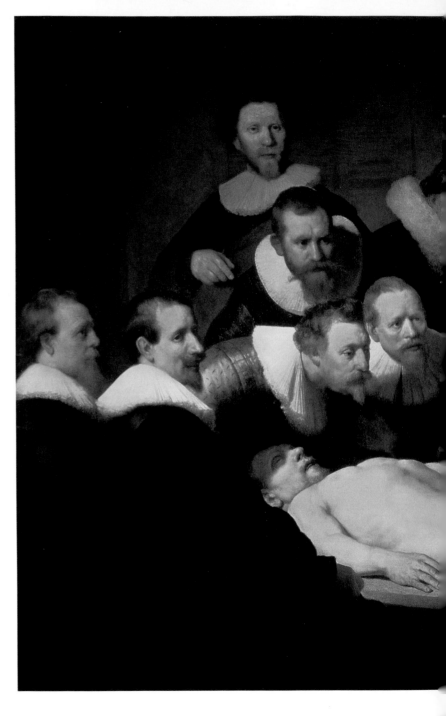

Rembrandt Harmenszoon van Rijn
The Anatomy Lesson of Dr. Nicolaes Tulp 1632 Oil on canvas
Mauritshuis, The Hague, Netherlands

THE ANATOMY LESS

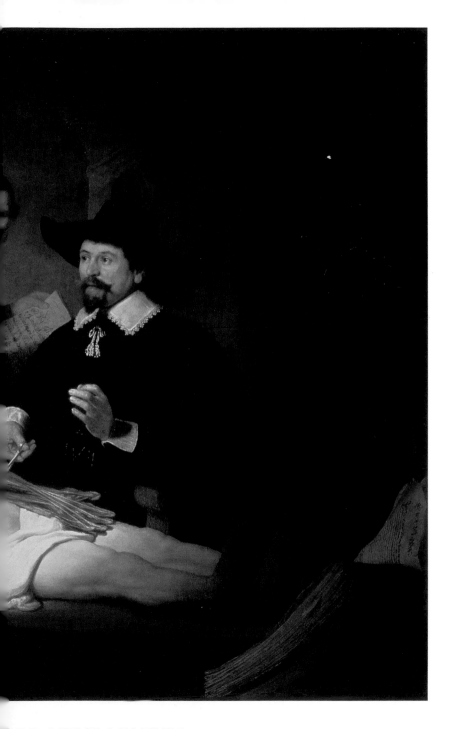

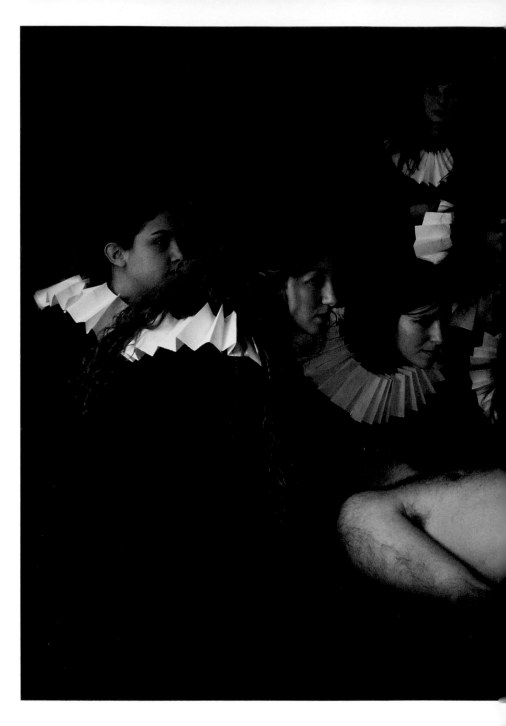

Avi Naim

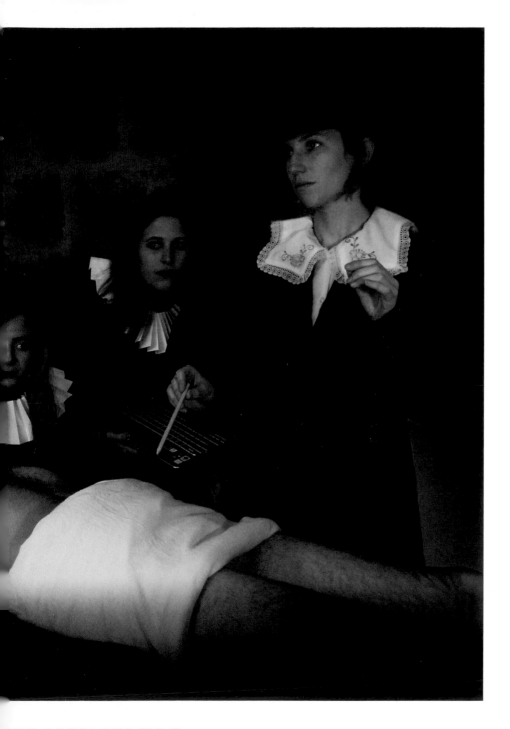

DR. NICOLAES TULP

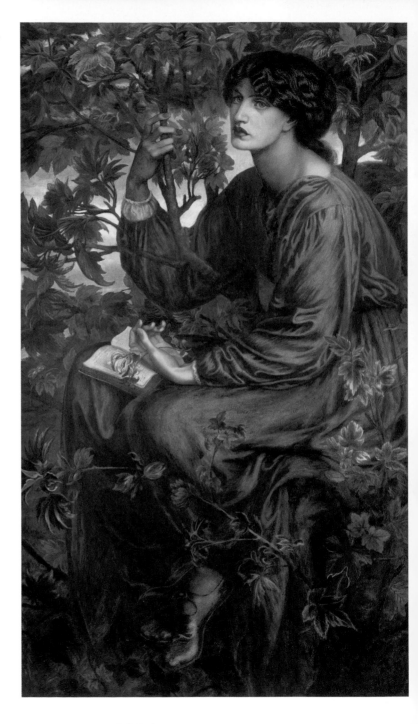

Dante Charles Gabriel Rossetti
Day Dream 1880 Oil on canvas
Victoria and Albert Museum, London, UK

DAY DREAM

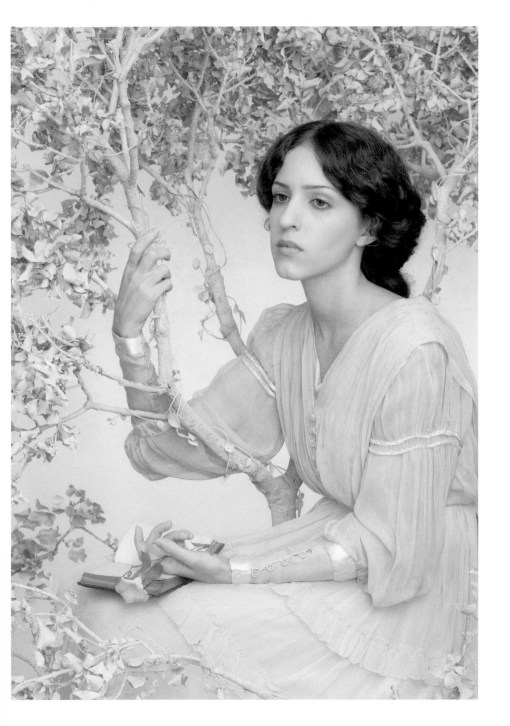

Tania Brassesco and Lazlo Passi Norberto

DAY DREAM

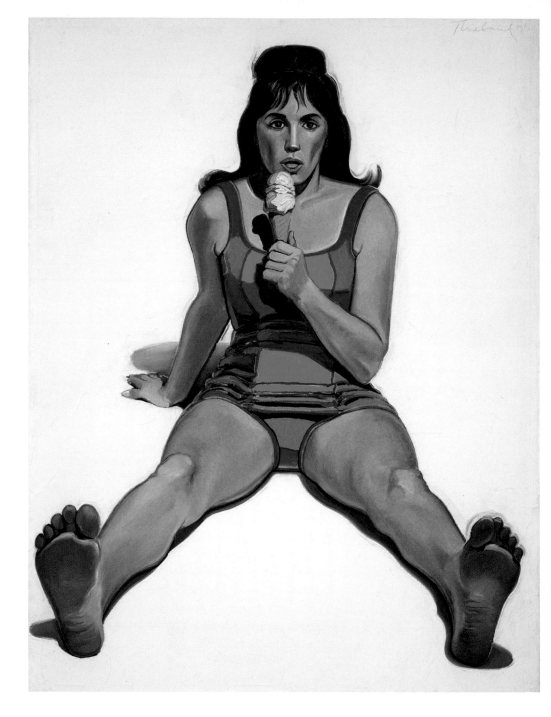

GIRL WITH ICE CREAM CONE

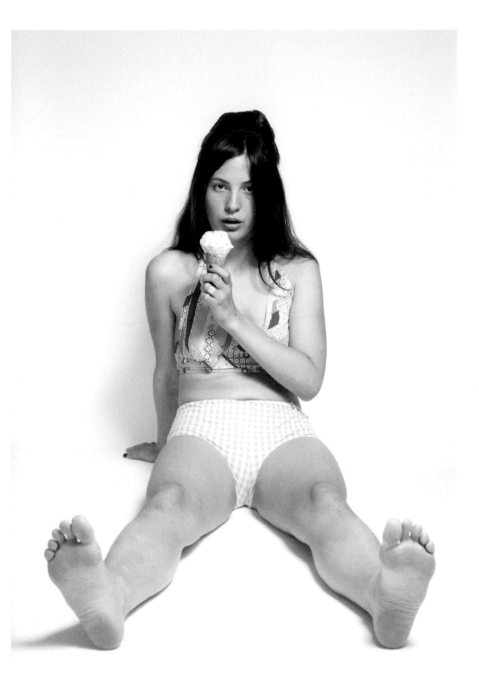

GIRL WITH ICE CREAM CONE

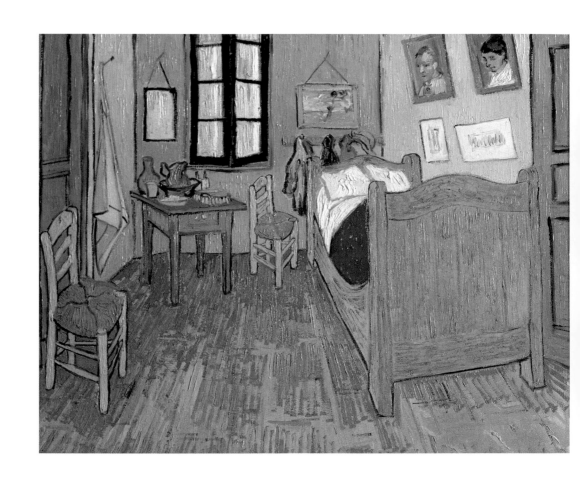

Vincent van Gogh
Van Gogh's Bedroom at Arles 1889 Oil on canvas
Musée d'Orsay, Paris, France

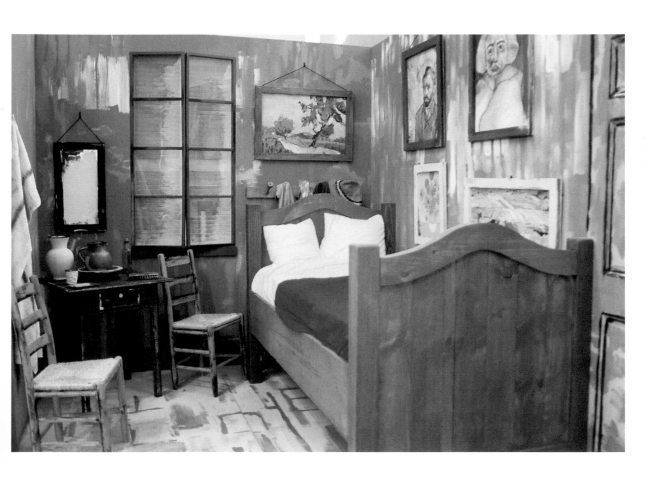

Joshua Louis Simon with help from Jenna Weiss,
Alex Friedman, and Mike Martin

VAN GOGH'S BEDROOM AT ARLES

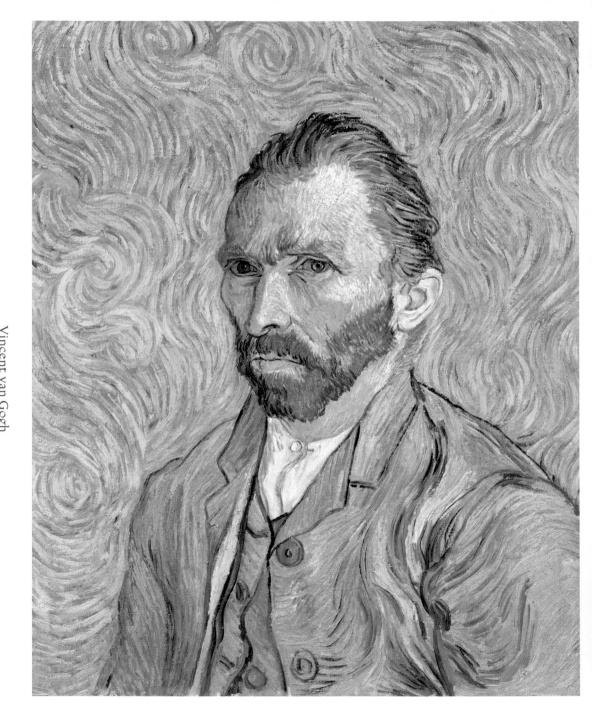

Vincent van Gogh
Self-Portrait 1889 Oil on canvas
Musée d'Orsay, Paris, France

SELF-PORTRAIT

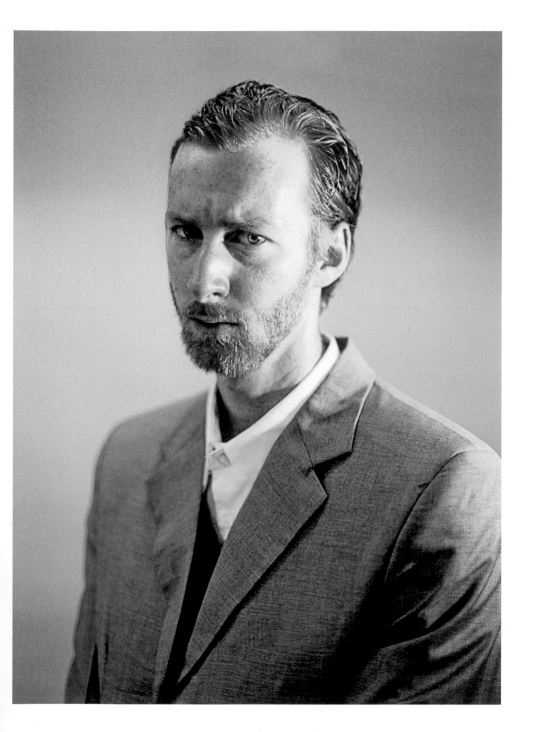

SELF-PORTRAIT

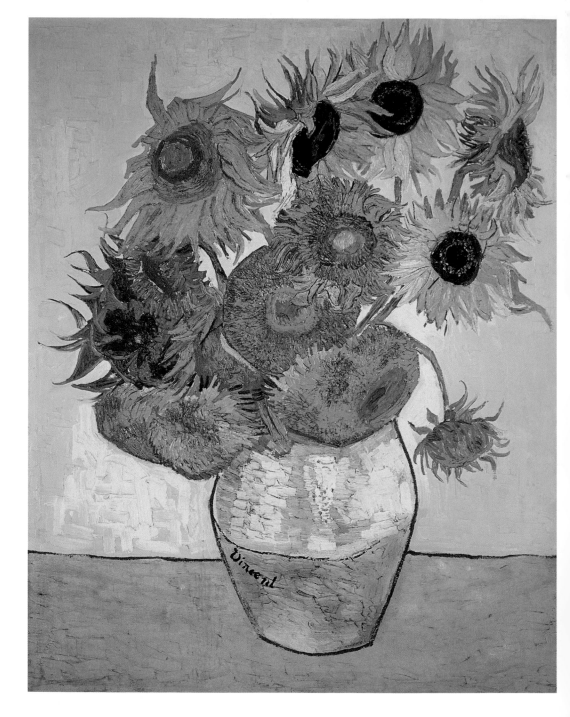

Vincent van Gogh
Sunflowers 1888 Oil on canvas
Neue Pinakothek. Munich. Germany

SUNFLOWERS

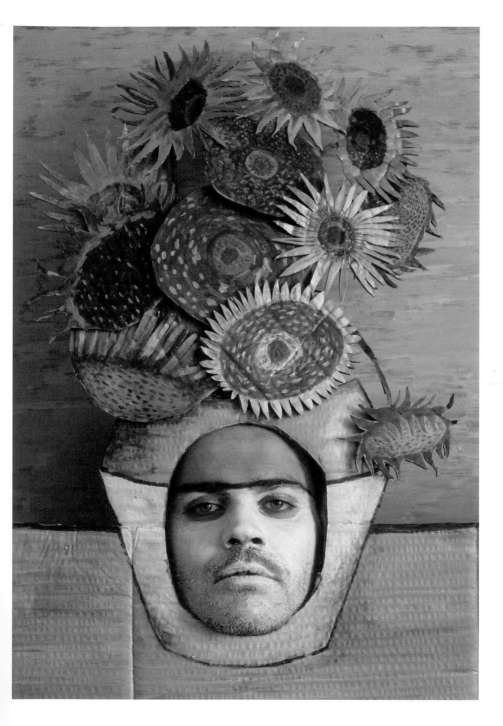

SUNFLOWERS

Jan (Johannes) Vermeer
The Milkmaid c. 1658–60 Oil on canvas
Rijksmuseum. Amsterdam. Netherlands

THE MILKMAID

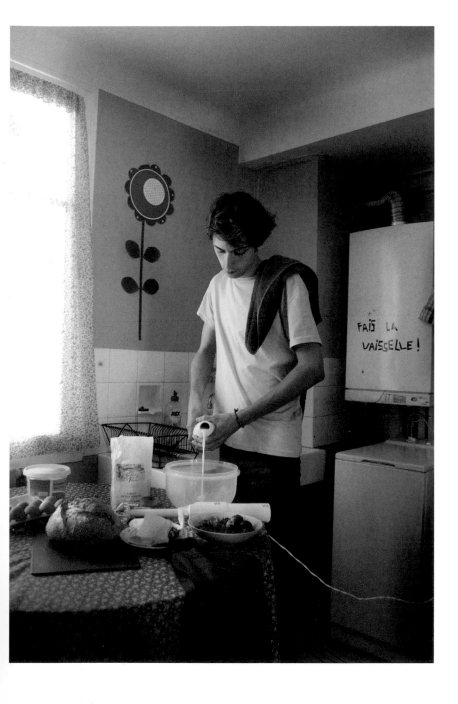

Justine Rioufrait

THE MILKMAID

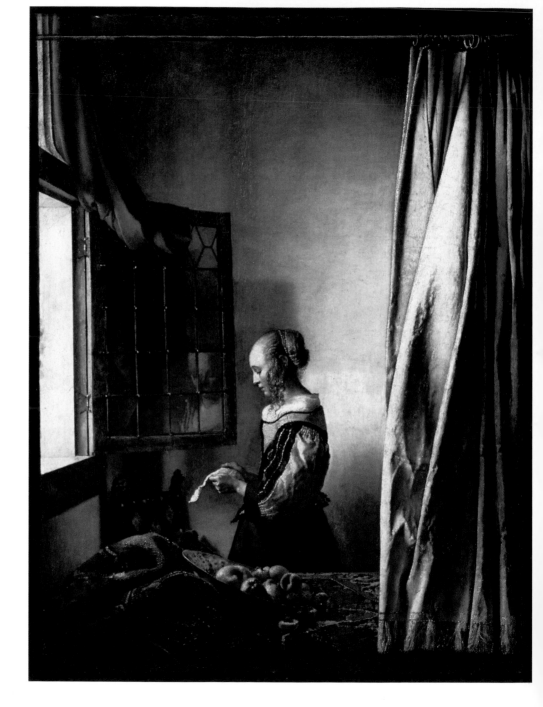

Jan (Johannes) Vermeer
Girl at a Window Reading a Letter 1659 Oil on canvas
Gemaeldegalerie Alte Meister, Dresden, Germany

GIRL AT A WINDOW READING A LETTER

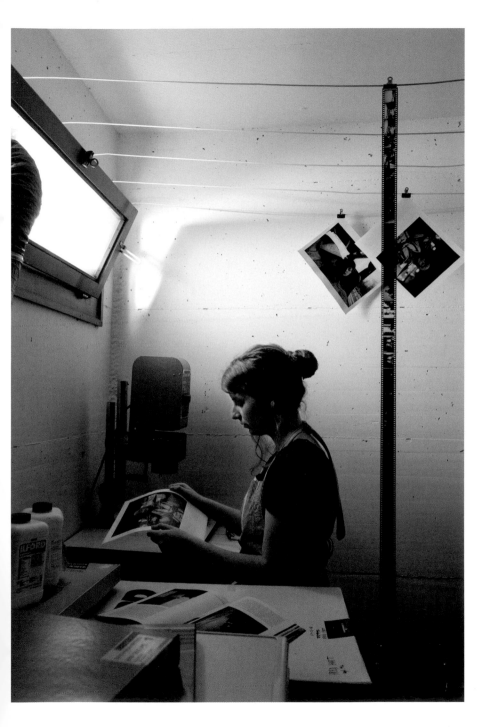

Johann Watzke

GIRL AT A WINDOW READING A LETTER

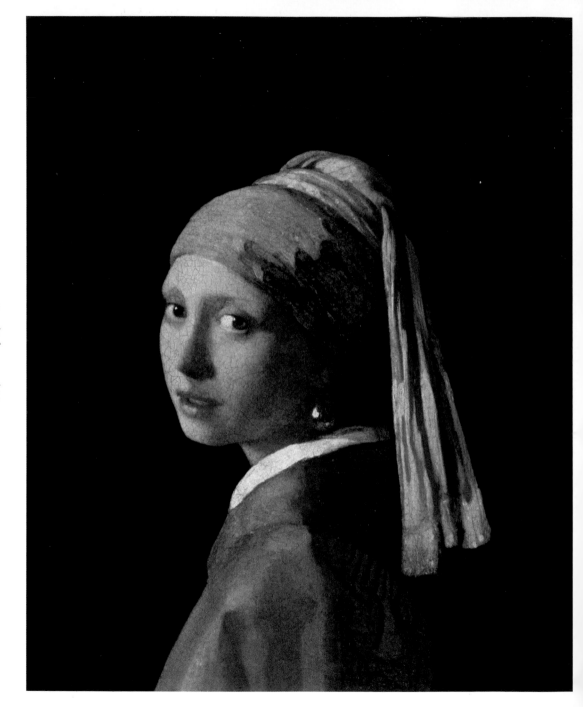

Jan (Johannes) Vermeer
Girl with a Pearl Earring c. 1665–66 Oil on canvas
Mauritshuis, The Hague, Netherlands

GIRL WITH A PEARL EARRING

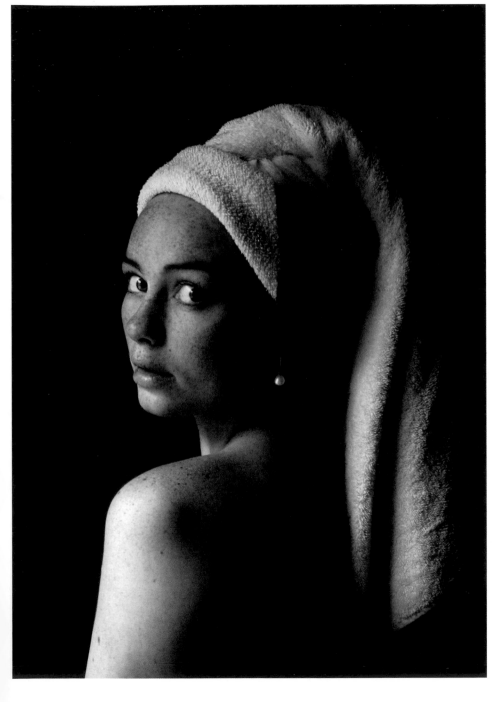

Erica Phillips

GIRL WITH A PEARL EARRING

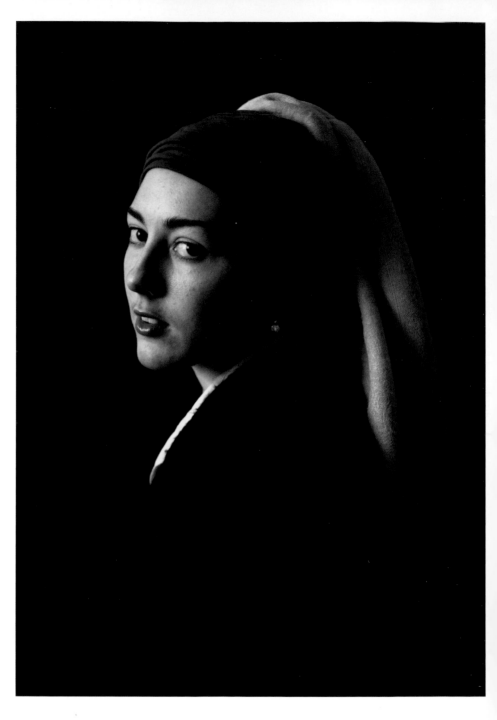

112 GIRL WITH A PEARL EARRING

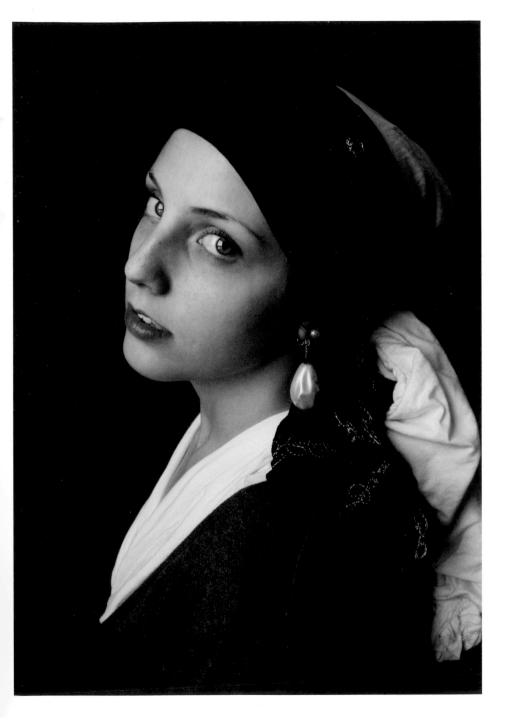

Alex Willms

GIRL WITH A PEARL EARRING 113

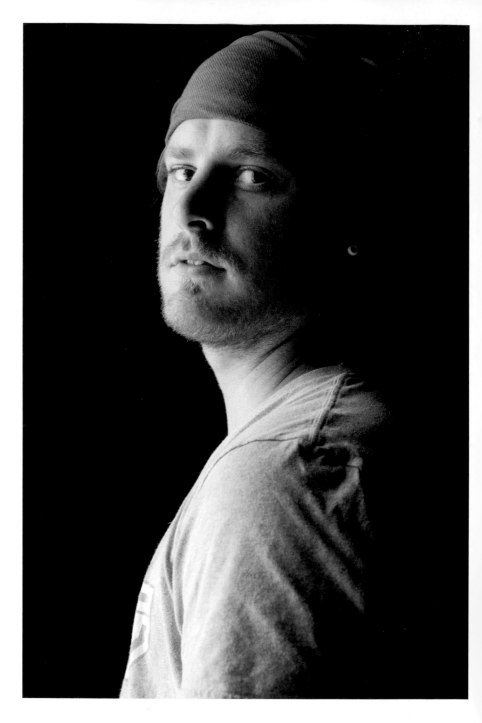

GIRL WITH A PEARL EARRING

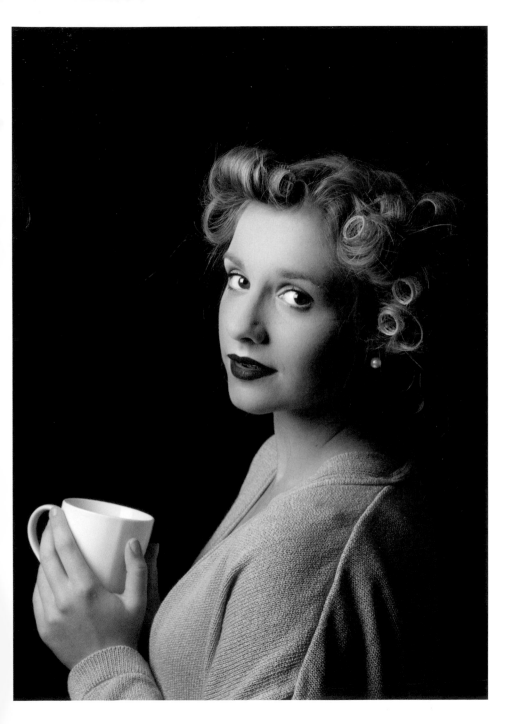

GIRL WITH A PEARL EARRING

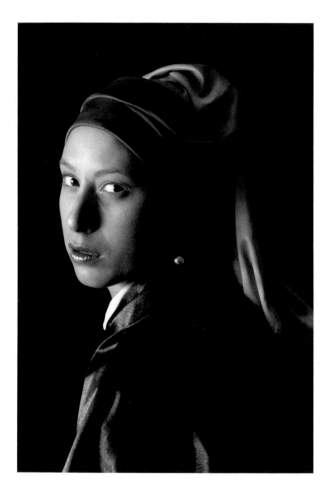
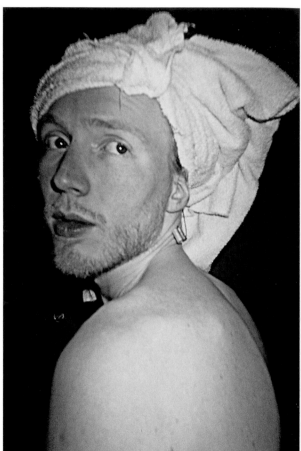

left: Giuliana Blanchet; right: Kaleena Spackman

GIRL WITH A PEARL EARRING

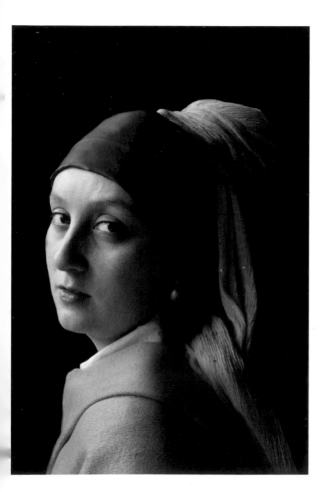

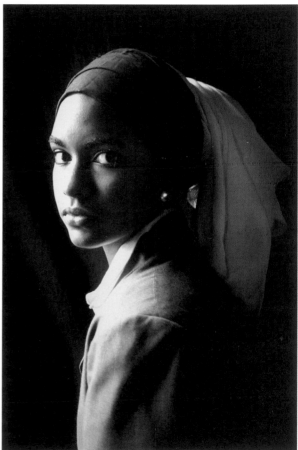

left: Martha Rodriguez; right: Melissa Montero

GIRL WITH A PEARL EARRING 117

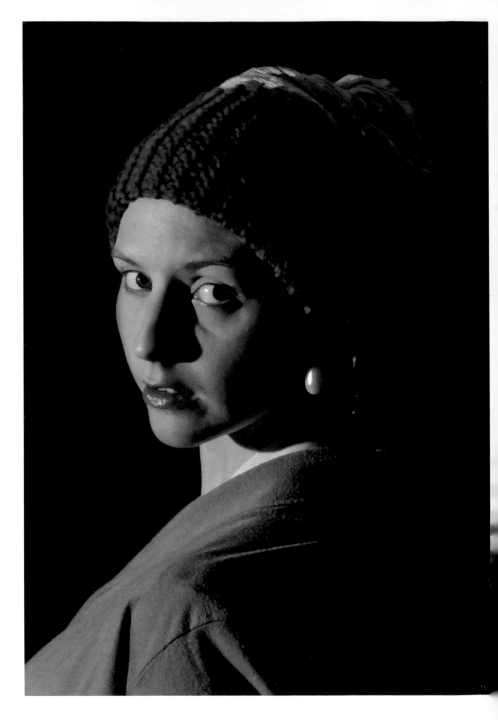

Rebekah Alviani

GIRL WITH A PEARL EARRING

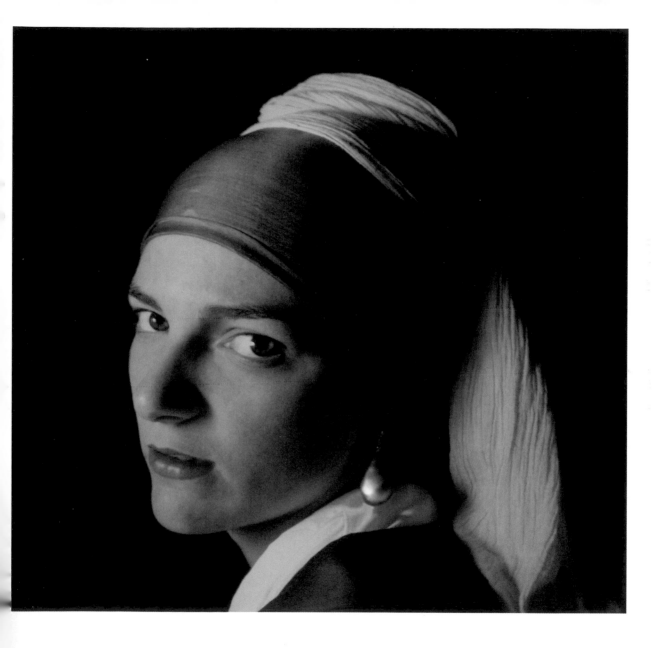

Sybille de Chavagnac and Guillemette de Penfentenyo

GIRL WITH A PEARL EARRING 119

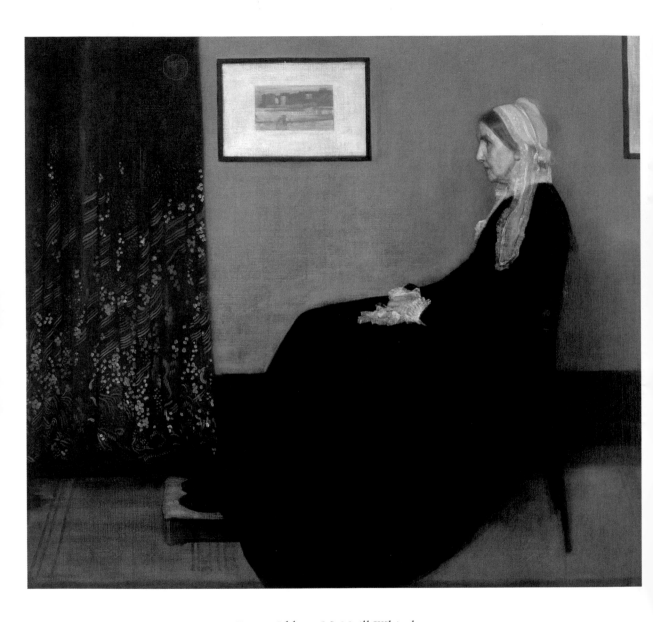

James Abbott McNeill Whistler
Arrangement in Grey and Black No. 1, Portrait of the Artist's Mother 1871 Oil on canvas
Musée d'Orsay, Paris, France

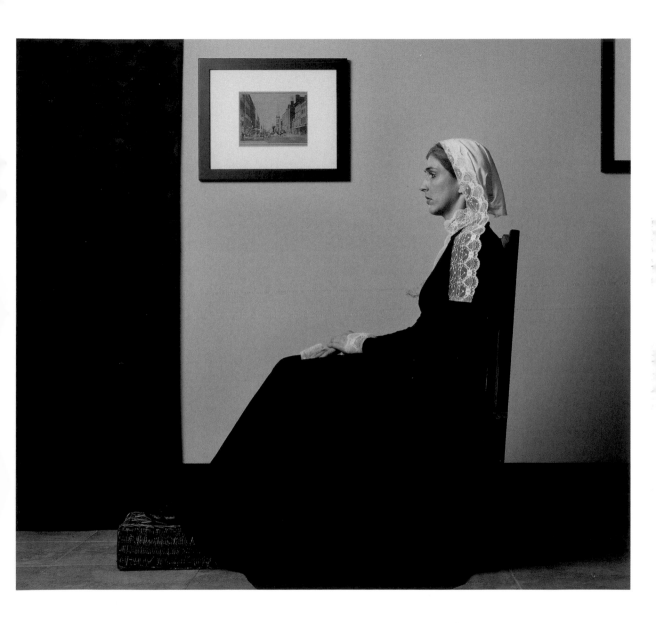

Jeff DeMarco

PORTRAIT OF THE ARTIST'S MOTHER 121

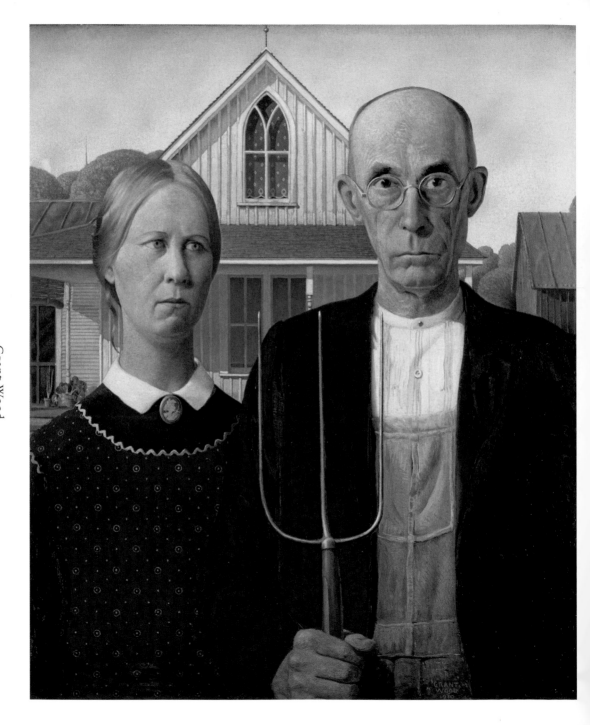

Grant Wood
American Gothic 1930 Oil on board
The Art Institute of Chicago, Chicago, IL, USA

AMERICAN GOTHIC

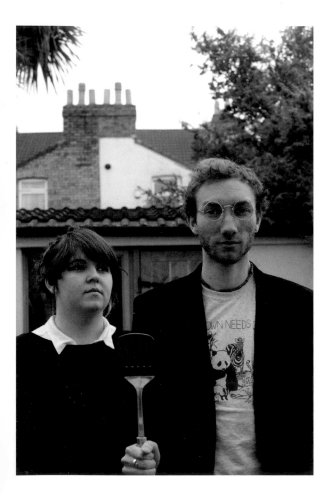

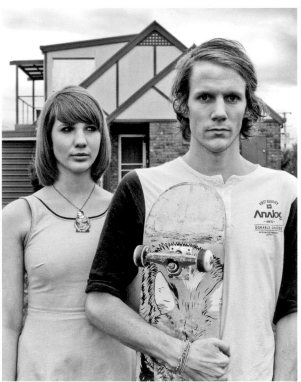

left: Chris Price, Zoe L'estrange, and Luke Frisby;
right: Jesse Hunniford

AMERICAN GOTHIC 123

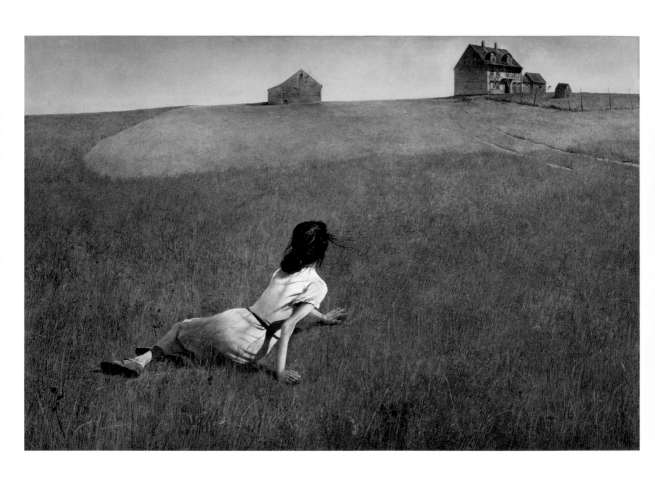

Andrew Wyeth
Christina's World 1948 Tempera on panel
The Museum of Modern Art, New York, NY, USA

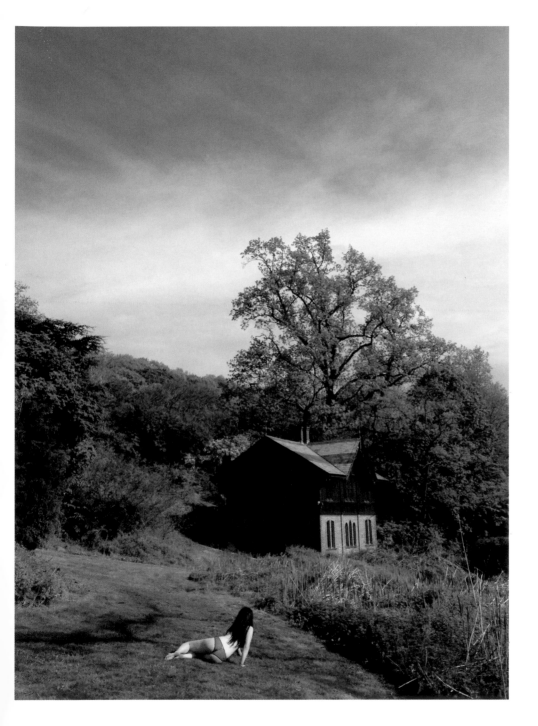

CHRISTINA'S WORLD

William-Adolphe
Bouguereau,
The Little Shepherdess
Gift of Laura A. Clubb,
1947.8.82,
© 2015 Philbrook Museum
of Art, Inc., Tulsa,
Oklahoma

Caravaggio, *Narcissus*
Photo: The Bridgeman
Art Library

Annibale Carracci,
The Bean Eater
© Mondadori Electa
Photo: The Bridgeman
Art Library

Ramon Casas i Carbó,
After the Ball
Photo: Index / The
Bridgeman Art Library

Leonardo da Vinci,
*The Lady with the Ermine
(Cecilia Gallerani)*
© Czartoryski Museum,
Cracow, Poland
Photo: The Bridgeman
Art Library

Leonardo da Vinci,
The Last Supper
Photo: The Bridgeman
Art Library

Salvador Dali,
The Ship
© Salvador Dali, Fundació

Gala–Salvador Dali, Artist
Rights Society (ARS)
New York 2014
Photo: The Bridgeman
Art Library

Jacques-Louis David,
The Death of Marat
Photo: The Bridgeman
Art Library

Herbert James Draper,
Pot Pourri
© The Maas Gallery,
London
Photo: The Bridgeman
Art Library

Jean-Honoré Fragonard,
Young Girl Reading
Photo: The Bridgeman
Art Library

Caspar David Friedrich,
*The Wanderer above
the Sea of Fog*
Photo: The Bridgeman
Art Library

Francisco Goya,
*Saturn Devouring One of
His Sons*
Photo: The Bridgeman
Art Library

Edward Hopper,
Nighthawks
33 ⅛ x 60 in
(84.1 x 152.4 cm)
1942.51

Photo: The Art
Institute of Chicago

Edward Hopper,
Morning Sun
Columbus Museum of
Art, Ohio; Howald Fund
Purchase, 1954.031

Jean-Auguste-Dominique
Ingres,
The Grand Odalisque
Photo: Giraudon / The
Bridgeman Art Library

Jean-Auguste-Dominique
Ingres, *Napoleon I
(1769–1821)
on the Imperial Throne*
Photo: Giraudon
/ The Bridgeman Art
Library

Frida Kahlo,
The Broken Column
Photo: Schalkwijk
/ Art Resource, NY

Frida Kahlo,
*Self-Portrait as Tehuana
or Diego in My Mind*
© ARS, NY
Photo: Erich Lessing
/ Art Resource, NY

Frida Kahlo,
The Two Fridas
© 2014 Banco de México
Diego Rivera Frida Kahlo
Museum Trust, Mexico

D.F. / Artist Rights
Society (ARS), New York
Photo: De Agostini
Picture Library / The
Bridgeman Art Library

Gustav Klimt,
The Kiss
Photo: The Bridgeman
Art Library

Roy Lichenstein,
*Oh, Jeff… I Love You, Too…
But…*
© Estate of Roy
Lichtenstein

Roy Lichenstein,
Ohhh… Alright…
© Estate of Roy
Lichtenstein

René Magritte,
The Menaced Assassin
© 2014 C. Herscovici/
Artist Rights Society
(ARS), New York
Digital Image
© The Museum of
Modern Art / Licensed
by SCALA / Art
Resource, NY

René Magritte,
The Lovers
59 ¼ in x 6 ft 4 ⅞ in
(150.4 x 195.2 cm)
Kay Sage Tanguy Fund
© 2014 C. Herscovici/
Artist Rights Society

REMAKE